LEGENDARY

—— OF ——

ELIZABETH CITY

NORTH CAROLINA

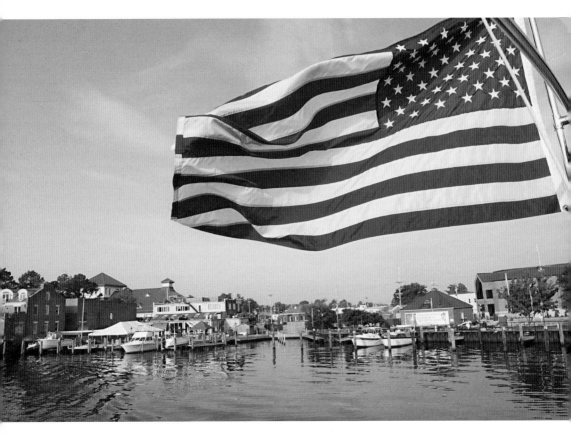

Harbor of Hospitality
The American flag flies proudly over the Elizabeth City waterfront—the Harbor of Hospitality. (Courtesy of Elizabeth City Area Convention and Visitors Bureau.)

Page 1: **Shriners' Club Parade**
An Elizabeth City Shrine Club parade winds its way down Main Street in the early 1900s. (Courtesy of Marian Stokes.)

LEGENDARY LOCALS

—— OF ——

ELIZABETH CITY

NORTH CAROLINA

MARJORIE ANN BERRY

Legendary Locals is an imprint of Arcadia Publishing
Charleston, South Carolina

Printed in the United States of America

Library of Congress Control Number: 2014931173

For all general information, please contact Arcadia Publishing:
Telephone 843-853-2070
Fax 843-853-0044
E-mail sales@arcadiapublishing.com
For customer service and orders:
Toll-Free 1-888-313-2665

Visit us on the Internet at www.arcadiapublishing.com

Dedication
This book is written on behalf of the Elizabeth City Historic Neighborhood Association, a nonprofit group. All of the author's royalties from the sale of this book go toward historic preservation in and around Elizabeth City, North Carolina.

On the Front Cover: Clockwise from top left:
Walter E. "Stalk" Comstock, owner of Comstock's Confectionary (Courtesy of Ed Comstock; see page 106), Wilbur and Orville Wright, aviation pioneers (Courtesy of Library of Congress; see page 66), Theodosia Burr Alston, Aaron Burr's daughter (Courtesy of Horace Walpole Library, Yale University; see page 31), William Henry Weatherly, owner of Weatherly Candy Company (Courtesy of Museum of the Albemarle; see page 57), George Monck, Duke of Albemarle (Courtesy of Museum of the Albemarle; see page 13), William O. Saunders, journalist and founder of the *Independent* (Courtesy of Museum of the Albemarle; see page 70), Hattie Matthews Harney, educator (Courtesy of Museum of the Albemarle; see page 101), Wittier Crockett "W.C." Witherspoon, educator (Courtesy of W.C. Witherspoon Library; see page 111), Jim Wilcox, accused murderer (Courtesy of Museum of the Albemarle; see page 68).

On the Back Cover: From left to right:
Elizabeth City High School Band and patron Miles Clark (Courtesy of Museum of the Albemarle; see page 102), Peter Weddick "P.W." Moore, educator at State Normal School (Courtesy of Elizabeth City State University; see page 51).

CONTENTS

ACKNOWLEDGMENTS

I wish to thank the following people for their assistance: Jean Baker, Kathy Blades, Ed and Norma Comstock, Patrick Detwiler, Craig Egan, Liza Franco, Leonard Lanier, Jamie McCargo, Wanda Lassiter, Cookie Stokes, Mary Tirak, and Tim and Cindy Williams.

INTRODUCTION

Elizabeth City lies at a narrow bend in the Pasquotank River in northeastern North Carolina. It was incorporated as a town in 1793 but was inhabited much earlier. The first inhabitants were Native Americans of the Algonquin tribe. European settlers arrived, not from the nearby sea coast, but trickled down from Virginia in the 1600s. The area's first settler was believed to be Nathaniel Batts, whose name appears on a map dated 1657.

Because of its location, Elizabeth City became a port and center for trade early on. It was known simply as The Narrows. Later, it was called Shingle Landing, because of the large number of cypress shingles that passed through the port. There was a thriving trade with the West Indies in the 1700s, and ocean-going ships lined the waterfront.

In 1793, a charter was granted by the General Assembly to establish a town at the narrows of the Pasquotank River. The town was called Reding, after some long-forgotten family. The following year, the legislature changed the name to Elizabeth Town. The town grew and thrived so quickly that in 1799 it became the county seat of Pasquotank County. In 1801, the name was changed to Elizabeth City. Legend has it that Elizabeth City was named for Elizabeth Tooley, who, along with her husband, Adam, sold the land on which the town was established. It is also possible that Elizabeth City was named for Elizabeth City County, Virginia, from which many settlers came.

The opening of the Dismal Swamp Canal in the early 1800s connected Elizabeth City with Norfolk, Virginia, and ushered in a time of great prosperity. Elizabeth City thrived until the Civil War, which had a devastating effect on the town. Occupation by Union troops for most of the war created fear and misery among the townspeople. The Reconstruction Era was even worse, with its cruel and unjust carpetbag government.

It was not until the 1880s that prosperity arrived along with a rail connection to the outside world. The Elizabeth City and Norfolk Railroad was completed in 1881 to great fanfare. The town's economic fortunes improved as a result.

The turn of the 20th century brought two brothers from Ohio who would make aviation history. For Wilbur and Orville Wright, Elizabeth City was the first leg of their journey to Kitty Hawk. Arriving here by train, the Wrights would then catch a fishing boat on to the Outer Banks.

The 1901 murder of "Beautiful Nell" Cropsey turned the town on its ear. Nell's beau, the hapless Jim Wilcox, was quickly convicted in the court of public opinion. His trial was the biggest hoopla the town has ever seen, though the murder remains unsolved.

Shipyards, lumbering, oyster canneries, and agriculture were Elizabeth City's major industries in the early part of the century. Businesses were started following the Civil War, and they grew and thrived, especially the lumbering business, dominated by the Kramer, Blades, and Foreman families. The Great Depression of the 1930s created an economic downturn in Elizabeth City, as it did all over America. World War II brought two military installations to town—a US Coast Guard base that remains a major employer today, and a naval airship operation that was utilized to locate German U-boats along the coast.

The second half of the 20th century was a prosperous, peaceful time for the town. A festival was created to celebrate the area's number one crop: the Irish potato. The Albemarle Potato Festival, begun in 1940, continues today as the North Carolina Potato Festival. The Elizabeth City High School marching band, under the patronage of wealthy oil distributor Miles Clark, became prominent in the region, performing at the annual First Flight celebrations at Kitty Hawk and the Oyster Bowl football games in Norfolk, Virginia.

Two local men, Joe Kramer and Fred Fearing, started the Rose Buddies in the 1980s. They welcomed boaters to the town's waterfront with wine and cheese parties and homegrown roses, attracting

international attention. The Rose Buddies continue today as a dedicated group of volunteers continuing to welcome the world to Elizabeth City's door via the Intracoastal Waterway.

Elizabeth City today is a town of some 19,000 residents, with another 17,000 in surrounding Pasquotank County. Agriculture remains an economic force, along with a US Coast Guard base that boasts seven commands and a regional hospital. Tourism and a creative economy are increasingly important in the area. A state-of-the-art waterfront museum interprets the history of the 13 counties of North Carolina's northeast, while a historic downtown landmark has been transformed into a gleaming center for the arts.

Elizabeth City is a modern Southern town that looks ever to the future but is richly endowed with the legends and lore of the past.

CHAPTER ONE

Exploration and Settlement

In 1584, a party of English explorers sailed into the Albemarle Sound and up the Pasquotank River. They were likely the first Europeans to set foot in what is now Elizabeth City. Here, they found Algonquin Indian tribes who had lived undisturbed for thousands of years.

It was not until the 1650s that settlers began to trickle down from the tidewater area of Virginia. Nathaniel Batts is credited with being the first Tar Heel, his name appearing on a 1657 map of what is now northeastern North Carolina. In 1663, Governor Berkeley of Virginia issued patents for 28 tracts of land in the area. That same year, King Charles II of England granted land to eight Lords Proprietors, men who had supported him in the English civil war. This Propriety of Carolina included "Pasquotank Precinct," which encompasses present-day Elizabeth City. The northern part of the propriety was dubbed "Albemarle" after George Monck, Duke of Albemarle, one of the eight proprietors.

The early settlers were a hard-working, fiercely independent people. They wanted the least possible government intrusion in their lives. Most trade was of tobacco since none but the very wealthy had money. There were no roads; people traveled by boat along the many creeks and rivers of the area. Social opportunities were so scarce that sessions of court were major events, each planter bringing his entire family to court to trade and have social interaction.

An event known as Culpeper's Rebellion took place on the shores of the Pasquotank River in December 1677. Partly a protest against the Navigation Act, Culpeper's Rebellion is considered the earliest strike against government tyranny in America.

In 1728, Carolina was made a royal colony, the Lords Proprietors having fallen out of favor as a governing body. Pasquotank Precinct then became Pasquotank County.

The Revolutionary War had little immediate impact on the area, since no battles were fought on local soil. In 1793, a town was chartered at the narrows of the Pasquotank River. It was first called Redding, then Elizabeth Town. Finally, in 1801, Elizabeth City was born.

The Algonquin Indians

The first European explorers in northeastern North Carolina encountered an indigenous people who were part of the Algonquin tribe. Capt. John White, a participant in Sir Walter Raleigh's attempt at English colonization along the North Carolina coast, immortalized many of the natives in watercolors such as the one below. The Indians living along the Pasquotank River were known as "Weapomiok" or "Yeopim." The name Pasquotank is from the Algonquin, "Pasketanki," meaning where the stream forks or divides. These natives were farmers, hunters, and fisherman. Their principal town was located on the present-day site of Elizabeth City. It was known as "Women's Town," possibly because women outnumbered men in the settlement. Initially, the Algonquin were very friendly to the English newcomers, and the early settlers regarded the Indians as "the true lords of the soil." However, English expansion steadily encroached on native lands and threatened the Indians' way of life, even as white men's diseases reduced their numbers. There were also several wars between settlers and Indians in the early years of settlement. Eventually, Pasquotank's Indians either left the area or were assimilated into the settlers' culture. (Courtesy of British Museum.)

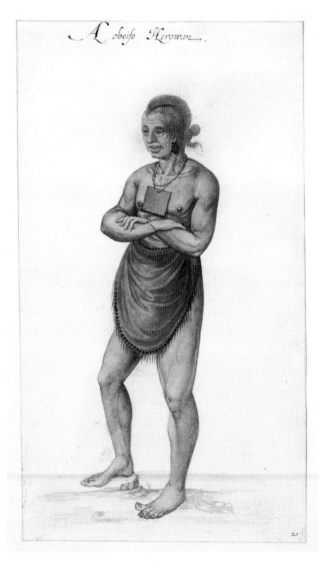

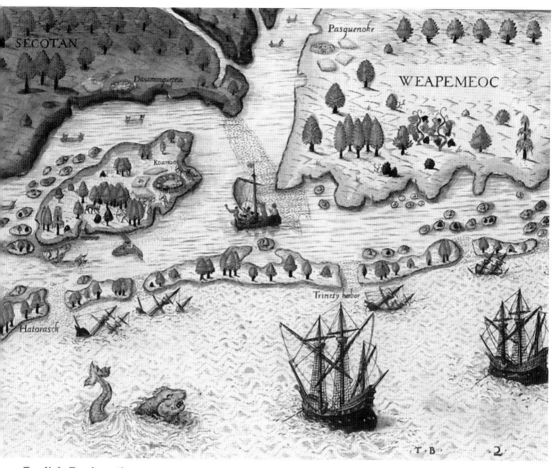

English Exploration

Sir Walter Raleigh was not only anxious to establish a colony in the New World, he was also hoping to discover gold and other precious metals with which to impress Queen Elizabeth I. He sent a military contingent to make a foray into what is now eastern North Carolina in 1585. English soldiers Philip Amadas and Arthur Barlowe led an exploring party into the region. These 14 men were the first Englishmen to lay eyes on what is now Elizabeth City. The party had sailed from Roanoke Island through the Albemarle Sound and up the Pasquotank and Chowan Rivers. The Indians they found were friendly and hospitable. There were some problems with the language, however. A great misunderstanding occurred about the Indians' name for the area. They kept repeating the word "wingandacoa." Amadas and Barlowe documented this as the official place name on their maps and documents, only to find out that *wingandacoa* means "what pretty clothes you have." (Courtesy of the British Museum.)

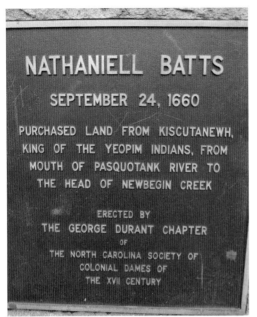

NATHANIELL BATTS

SEPTEMBER 24, 1660

PURCHASED LAND FROM KISCUTANEWH,
KING OF THE YEOPIM INDIANS, FROM
MOUTH OF PASQUOTANK RIVER TO
THE HEAD OF NEWBEGIN CREEK

ERECTED BY
THE GEORGE DURANT CHAPTER
OF
THE NORTH CAROLINA SOCIETY OF
COLONIAL DAMES OF
THE XVII CENTURY

Nathaniel Batts

In the mid-17th century, settlers from southeastern Virginia began immigrating to northeastern North Carolina, following Indian trails south through the Great Dismal Swamp. Nathaniel Batts, a hunter, trapper, and trader, was among the earliest settlers. Quaker missionaries George Fox and William Edmondson, traveling through northeastern North Carolina in the 1670s, both mention Batts in their writings. Most importantly, the first recorded deed in North Carolina was between Nathaniel Batts and the king of the Yausapin Indians, Kiscutanewh. Batts purchased thousands of acres in what is now the southern tip of Pasquotank County on September 24, 1660. The deed included, "All ye land on ye southwest side of Pascotank River from ye mouth of said river to ye head of New Begin Creeke." (Author's collection.)

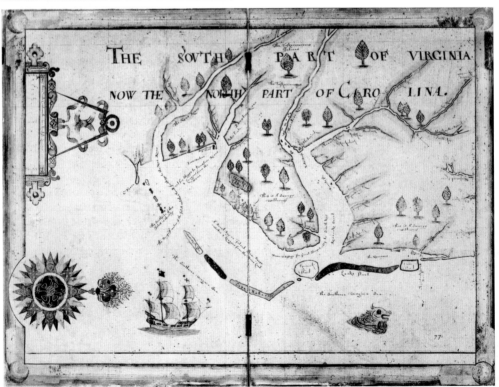

Batts's House on the Comberford Map

This 1657 map, known as the Comberford map, shows a drawing of a house at the mouth of the Roanoke River, labeled as "Batts House." Nathaniel Batts is believed to have been North Carolina's first settler. Historians refer to him as "the first Tar Heel." (Courtesy of North Carolina Archives.)

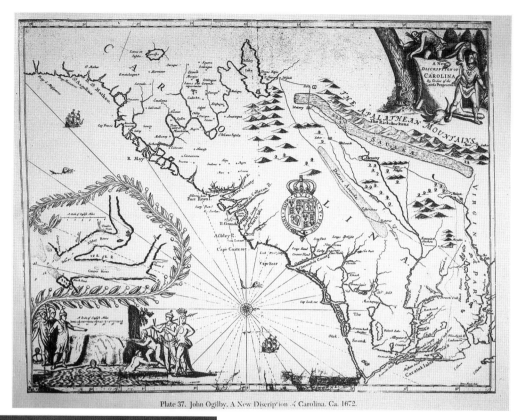

Plate 37. John Ogilby. A New Discription of Carolina. Ca. 1672.

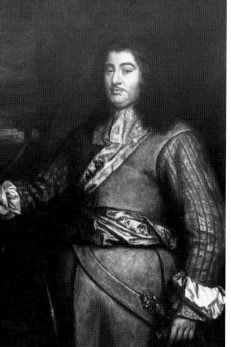

The Lords Proprietors of Carolina

When King Charles II was restored to the throne of England in 1663, he granted a large tract of land, in what are now North and South Carolina, to eight Lords Proprietors—men who had supported him during the English Civil War. The Lords Proprietors' rule was not welcome to an independent populace that was used to conducting their lives with little interference from government. This map of Carolina, created by John Ogilvy around 1672, was commissioned for the Lords Proprietors. (Courtesy of Museum of the Albemarle.)

George Monck, Duke of Albemarle

One of the eight Lords Proprietors, George Monck, was named Duke of Albemarle. The northern part of the propriety was dubbed Albemarle in his honor. This area included Pasquotank Precinct, where Elizabeth City exists now. Albemarle's boundaries extended from the Virginia border south to the Albemarle Sound, and from the Atlantic Ocean west to the Pacific. Even today, North Carolina's northeast is known as "the Albemarle." A perusal of Elizabeth City's telephone book will yield a plethora of businesses beginning with the word Albemarle. (Courtesy of Museum of the Albemarle.)

13

George Durant

George Durant was one of the earliest settlers of Albemarle and was certainly the most affluent. His descendants are numerous, and many of them still reside in the Albemarle. Durant was at the center of an early property dispute. In 1661, he purchased a tract of land from the Indians. When the Lords Proprietors came into power in 1663, George Catchmaid was granted a tract of land, which included part of the tract that Durant had purchased. Catchmaid agreed to honor Durant's prior claim, but died before he could write out an agreement. His widow married Timothy Biggs, a newcomer to Albemarle. Biggs refused to honor Catchmaid's agreement with Durant and took his land. The ensuing animosity created a rift in the settlement with the other settlers taking sides. There arose a Durant faction and a Biggs faction with much hostility between the two. (Courtesy of the North Carolina Collection, UNC-CH.)

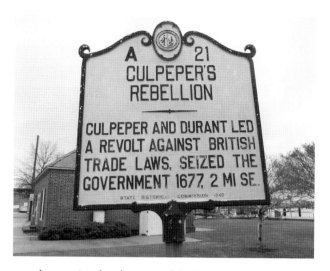

Culpeper's Rebellion

Culpeper's Rebellion (1677–1681) was one of America's earliest revolts against government tyranny. The events surrounding the rebellion read like a Colonial soap opera. Thomas Eastchurch, of the Biggs faction in Albemarle, traveled to London in 1676 along with Thomas Miller, a pompous, intemperate man known as the "apothecary of Pasquotank." They persuaded the Lords Proprietors to appoint Eastchurch governor of Albemarle, and Miller a deputy and collector of the king's customs. Instead of hurrying home to assume their new posts, the two men lingered several months to enjoy the pleasures of the London season. They stopped at the West Indies resort of Nevis on the way home where Eastchurch became enamored with a wealthy widow. Eastchurch stayed in Nevis to woo his lady, and sent Miller back to Albemarle as acting governor.

Once back home, Miller surrounded himself with a military guard, intimidated citizens, and made arbitrary arrests. He ruled an increasingly unhappy and hostile citizenry. George Durant traveled to London in the summer of 1677 in a futile attempt to persuade the Lords Proprietors of the unsuitability of Eastchurch and Miller, and urge them to appoint leaders from outside the colony.

The crisis came to a head in early December 1677 when the ship *Carolina* sailed up the Pasquotank River and docked at Relfe's Point. Settlers excitedly gathered there to hear news from abroad and buy goods. As soon as Capt. Zack Gillam stepped ashore, Miller charged him with a previous violation of the Navigation Acts. Gillam protested and threatened to sail away, which got the crowd on his side. Durant was secretly aboard the *Carolina*, having returned from London. Miller got wind of this and went aboard to arrest Durant for treason. The settlers must have been anticipating trouble, for at the news of Durant's arrest, 40 armed "Pasquotankians" revolted. The armed men included John Culpeper for whom the rebellion is named. They arrested Miller, along with Timothy Biggs and two other deputies, holding them at the plantation of William Jennings. The rebels issued a proclamation justifying the revolt and listing the grievances against Miller. A new government was established with John Culpeper as governor and collector of customs.

At this point, Thomas Eastchurch arrived in Virginia having wed the wealthy widow. Finding that his domain was in revolt and his enemies were now in power, he tried and failed to raise an army in Virginia to challenge the new government. Defeated, Eastchurch sickened and soon died.

Timothy Biggs managed to escape from prison and make his way to London. There, he tried to persuade the Lords Proprietors to overthrow the new government. By this time, the Lords Proprietors were weary of the colony. It had proved to be too much trouble and had yielded too little profit. They did concede to appoint one of their own, Seth Sothell, as governor of Carolina. Unfortunately for Biggs, Sothell was captured by pirates on the high seas, and never made it to America. An accounting of the revolt had to be made to the Crown, and John Culpeper was selected to travel to London to justify the rebels' actions. Miller then escaped from prison and sailed to London, where he persuaded the commissioners of customs to try Culpeper for treason for withholding revenue due the Crown. Culpeper was tried and acquitted in London in 1680.

In the end, Culpeper's Rebellion was a revolt against tyranny and unjust government. It was not, as some historians have suggested, a strike for independence against England, but the result of irresponsible and fractious governing in the young Carolina colony. (Author's collection.)

Frances Culpeper

A femme fatale of the Colonial era, Frances Culpeper used her charms to capture three Colonial governors. Frances, the sister of Colonial leader John Culpeper, was born in Hollingbourne, Kent, England. By 1652, she had immigrated to Virginia. That year, she married Samuel Stephens of Warwick County, Virginia, who was "commander of the southern plantation" (now northeastern North Carolina) from 1662 to 1664, and governor of Albemarle from 1667 until his death in 1670. In 1670, she married Sir William Berkeley, governor of Virginia. As Virginia's first lady, she lived in Green Spring, the governor's plantation home near Jamestown. The first of the James River plantation houses, the house featured a large center hall plan with a staircase—the first home in the colonies to sport such refinement. A supporter of Kings Charles II, Berkeley had been one of the eight Lords Proprietors of Carolina. He was appointed governor of Virginia in 1642. His early years as governor went well, but increasing political discord led to his downfall in Bacon's Rebellion in 1676. Frances, half his age, was his staunch supporter throughout all his difficulties. After Berkeley's death in 1677, she wed Col. Philip Ludwell Jr. of Virginia. Ludwell was commissioned "governor of that part of our Province of Carolina that lyes North and East of Cape Feare" in 1669. Having wed three Colonial governors, Frances died in 1690. She is buried in Jamestown, Virginia, her tombstone retaining her most prominent title: Francis, Lady Berkeley. Her portrait was painted by an unidentified artist in London around 1660 and has been passed down through the Ludwell family to their Lee descendants. (Courtesy of Museum of Early Southern Decorative Arts at Old Salem.)

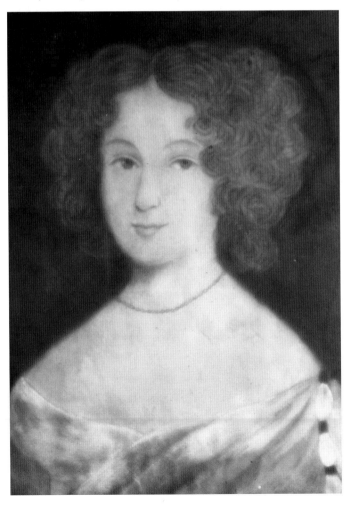

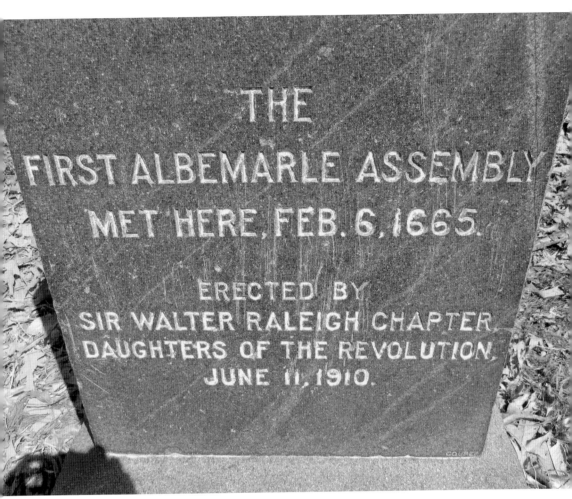

THE
FIRST ALBEMARLE ASSEMBLY
MET HERE, FEB. 6, 1665.

ERECTED BY
SIR WALTER RALEIGH CHAPTER,
DAUGHTERS OF THE REVOLUTION,
JUNE 11, 1910.

First General Assembly of North Carolina

Governor Drummond called the first General Assembly of Carolina in 1665. The Grand Assembly of the County of Albemarle was a gathering of six freeholders owning 50 acres or more. The session was held under a large oak tree on the banks of Hall's Creek in Pasquotank Precinct. The tree was known for many years as Assembly Oak. George Catchmaid served as speaker of the assembly, and George Durant was certainly one of the freeholders. The bylaws dictated that the members "must wear shoes, if not stockings during the session, and that they must not throw their chicken and other bones under the tree."

William Drummond was a Scotsman who came to Virginia as an indentured servant in the mid-1600s. As his fortunes increased, Drummond became a landowner and a prominent citizen of Jamestown. Governor Berkeley appointed him governor of Carolina during the regime of the Lords Proprietors. Drummond had his work cut out for him; he was charged with forming a state out of a few scattered families in the wilderness of Albemarle. These were a fiercely independent people who had lived an unrestricted existence. Drummond wisely set up a simple form of government that would not feel oppressive to the governed. Drummond also discovered a large circular lake in the middle of the Great Dismal Swamp. Lake Drummond bears his name today. (Author's collection.)

ON THIS SITE
THE FIRST PUBLIC SCHOOL
IN NORTH CAROLINA
WAS ESTABLISHED
1705
PRESENTED BY STATE COUNCIL
Jr. O. U. A. M. OF NORTH CAROLINA
1930

Charles Griffin

In 1705, the first school in North Carolina was established at Symonds Creek in Pasquotank Precinct. The first schoolmaster was the Reverend Charles Griffin, an Anglican minister. Griffin immigrated to the area from the West Indies, but little is known about his origins. By all accounts, he was an excellent schoolmaster and his school was a great success. Griffin later moved to Virginia, and Gov. Alexander Spottswood hired him to establish an Indian School to educate and "civilize" the natives. The school was closed in 1718 for lack of funding. Griffin then became master of the Indian School at the College of William and Mary in Williamsburg. Griffin disappears from history after this point, but he will be remembered as the first schoolmaster of the first school in North Carolina. (Author's collection.)

Blackbeard the Pirate

The most feared and famous of the Colonial buccaneers was Edward Teach, known as Blackbeard. Blackbeard was a familiar visitor to the coastal towns of North Carolina. To see his pirate ship sailing up the rivers of the Albemarle Sound was actually a welcome sight to the settlers. Merchants and homesteaders had many material needs and were happy to purchase Blackbeard's ill-gotten goods. He was such a menace to Colonial trade, however, that Governor Spottswood of Virginia sent Capt. Robert Maynard to end his reign of terror. Maynard's troops killed Blackbeard at Ocracoke in 1718, displaying his severed head on the bow of his ship, the *Queen Anne's Revenge*. Divers discovered the wreck of the *Queen Anne's Revenge* several years ago, salvaging cannons and other artifacts. (Courtesy of North Carolina Archives.)

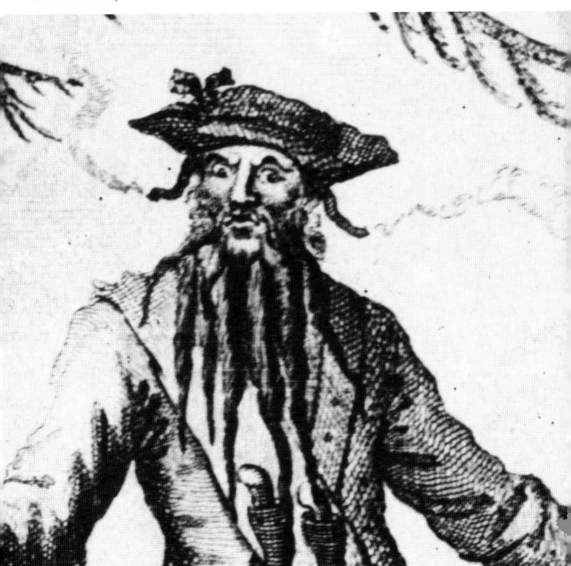

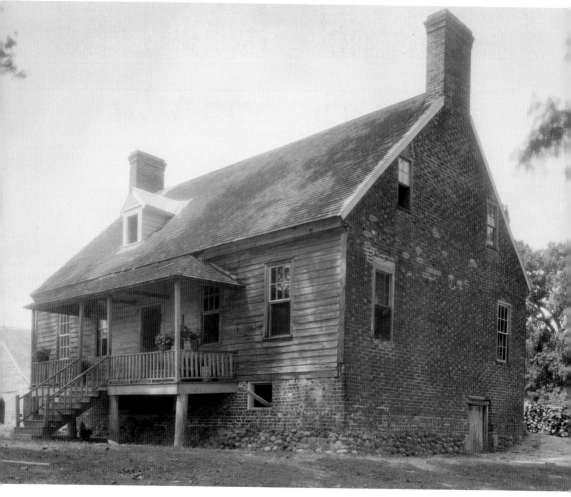

The Old Brick House
A legend persisted for many years that an old home on the Pasquotank River was Blackbeard's residence at one time. The Old Brick House, as it is known, had a secret passage leading to the home's basement. Mysterious stains on the floor hinted at Blackbeard's nefarious deeds. Alas, records show the house was built in about 1735 by an Englishman named Murden. Since Blackbeard was killed at Ocracoke in 1718, he could not have lived at the Old Brick House. The house still stands today and is a private residence. (Courtesy of Museum of the Albemarle.)

CHAPTER TWO

Prosperity and War

By 1801, the settlement at the narrows of the Pasquotank River would receive its fifth and final name: Elizabeth City. This thriving little town on the Pasquotank River became the county seat of Pasquotank County, and a committee was formed to build a courthouse, prison, pillory, and stocks. The opening of the Dismal Swamp Canal in 1805 caused an economic boom. Previously, the town's commerce was conducted by sea and travel by stagecoach. The opening of the canal connected Elizabeth City to the port of Norfolk, Virginia. Add to this a steamboat line to New Bern, and the town experienced tremendous growth. By 1829, half of the commerce of North Carolina passed through Elizabeth City.

The town's prosperity remained unchecked until the Civil War. The Battle of Elizabeth City, on February 10, 1862, was a naval skirmish on the Pasquotank River. It lasted less than 30 minutes but ushered in an era of economic downturn that was not relieved until the 1880s. In the battle, the Confederate Navy's "Mosquito Fleet" was no match for the better-equipped Union navy. When defeat was certain, the townspeople burned the courthouse and some of the better homes to keep them from the Yankee victors. Union troops occupied Elizabeth City for the rest of the war. It was a bitter time, made worse by the fact that the populace was sharply divided; many locals had remained loyal to the Union. A group of Confederate ex-prisoners paroled in Elizabeth City formed a guerrilla force that terrorized the town. The Union sent Gen. Edward Wild to quell the violence caused by this lawless group. Wild was ruthless and cruel in his occupation of the area, but the guerrilla activity ceased.

The years following the war were lean. Opportunistic carpetbaggers came from the north, buying up land and capitalizing on the economic downturn. Several schools were begun during this time to accommodate the influx of new students and make up for the lack of instruction during the war.

In 1881, the railroad came to connect Elizabeth City with the rest of the world. The Elizabeth City and Norfolk Railroad brought prosperity back to the area. The Dismal Swamp Canal was displaced as the major means of transportation and commerce and soon became the pleasure-boating passage it is today. Lumbering, oyster packing, textiles, and agriculture became the major industries of the region. Lumbering was especially lucrative, as lumber barons discovered the vast woodland resources of the area. As the century drew to a close, Elizabeth City was finally able to put the scars of war behind it and move on.

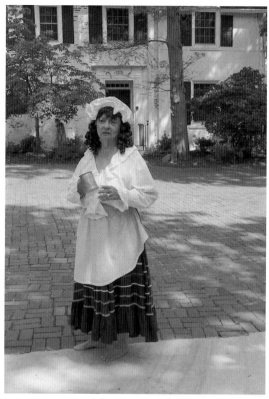

Elizabeth "Betsy" Tooley

Pictured at right, Evelyn Upton portrays Elizabeth "Betsy" Tooley in the Historic Elizabeth City Ghost Walk. Legend has it that Elizabeth City was named for Tooley who, along with her husband, Adam, sold 50 acres in 1794 to establish a town at the "Narrows of the Pasquotank River." The town was originally called Reding. It was changed later to Elizabethtown, and in 1801, to Elizabeth City. The Tooleys owned a tavern on what is now Water Street. Local lore says that Elizabeth Tooley operated the tavern herself, though it is unlikely that a wealthy landowner's wife would set foot in such a place. Was Elizabeth Tooley an aristocratic lady or a bawdy tavern-keeper? Only history knows for sure. (Right, courtesy of Jean Baker; below, courtesy of Museum of the Albemarle.)

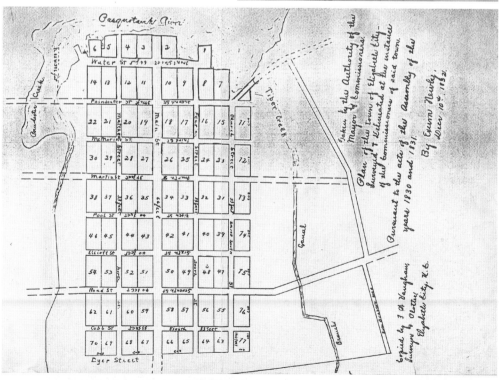

The Dismal Swamp Canal

The completion of the Dismal Swamp Canal in 1805 was an economic boon to Elizabeth City. Before its construction, goods had to be transported long distances by ocean-going ships. Overland transportation was not feasible, given that there were no good roads. The canal, begun in 1793, was dug completely by hand—mostly by slaves—and took 12 years to complete. It connected the Chesapeake Bay with the Albemarle Sound and opened up commerce between northeastern North Carolina and southeastern Virginia. The canal cut through the storied and mysterious Great Dismal Swamp that sprawls across the North Carolina–Virginia border. The swamp begins four miles south of Suffolk, Virginia, and extends southward to Elizabeth City. Once encompassing over 2,200 square miles, much of the swamp has been drained and reclaimed, leaving only about 600 square miles today. William Byrd II, surveying the North Carolina–Virginia line for the English Crown in 1728, called it "a vast body of dirt and nastiness." He dubbed it "dismal," a moniker

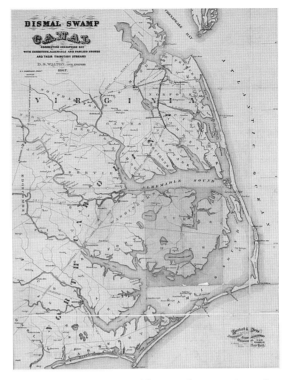

it bears today. The swamp actually contains an amazing variety of flora and fauna and exerts a brooding beauty. The coffee-colored, tannin-rich water of the canal became prized by sea captains for its ability to remain fresh on long voyages. The Dismal Swamp Canal began a decline in the late 19th century as railroads and other modes of transportation surpassed it for commercial use. It was sold to the federal government in 1929. Today, it is operated by the US Army Corps of Engineers and forms part of the Intracoastal Waterway. Over 2,000 pleasure boats sail through the canal every year. It is the oldest artificial waterway still in use in the United States. (Above, courtesy of US Army Corps of Engineers; below, courtesy of Elizabeth City Area Convention and Visitors Bureau.)

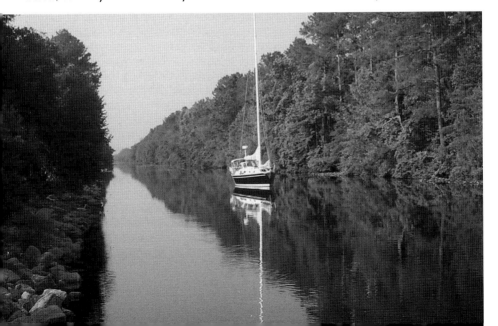

RULES OF THIS TAVERN

Four pence a night for Bed

Six pence with Supper

No more than five to sleep in one bed

No Boots to be worn in bed

Organ Grinders to sleep in the Wash house

No dogs allowed upstairs

No Beer allowed in the Kitchen

No Razor Grinders or Tinkers taken in

The Lake Drummond Hotel

Lake Drummond is an oval body of water, five by seven miles wide, in the heart of the Great Dismal Swamp. It was discovered in the 1600s by William Drummond, North Carolina's first Colonial governor. In 1829, Isaiah Rogerson erected a hotel near the lake, 10 miles southeast of Suffolk, Virginia. The Lake Drummond Hotel, also known as the Halfway House, became notorious as a haven for fugitives, elicit lovers, duelers, and thieves, mostly due to its isolated location. The 128-foot-long wooden building was centered on the state line, half in Virginia and half in North Carolina. Fugitives being pursued in either state could merely cross over to the other side of the building to avoid arrest. Legend has it that Edgar Allen Poe wrote his famous poem "The Raven" while staying at the Lake Drummond Hotel. It was also a popular honeymoon spot. By the 1850s, the hotel had fallen into disuse and disrepair. No vestige of it remains today. (Both, courtesy of Museum of the Albemarle.)

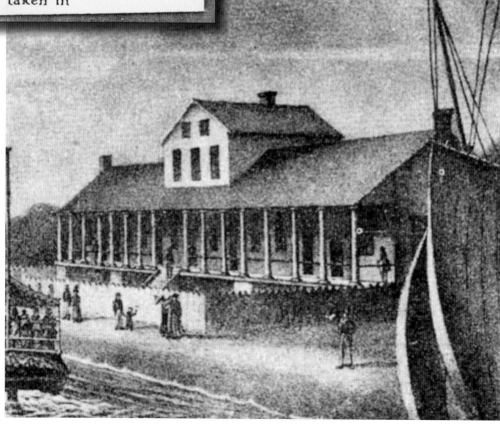

NARRATIVE

OF THE

LIFE OF

MOSES GRANDY;

LATE A SLAVE

IN THE

UNITED STATES OF AMERICA.

"Slavery is a mass, a system of enormities, which incontrovertibly bids
defiance to every regulation which ingenuity can devise, or power effect,
but a Total Extinction: Why ought slavery be abolished? Because it is
incurable injustice. Why is injustice to remain for a single hour?"
William Pitt.

PUBLISHED AND SOLD FOR THE BENEFIT OF HIS RELATIONS
STILL IN SLAVERY.

LONDON:
C. GILPIN, 5, BISHOPSGATE-STREET.

1843.

Moses Grandy

Moses Grandy was a maritime slave on the Pasquotank River who purchased his freedom three times. He was born in Camden, the property of Billy Grandy. Grandy was a hard-hearted man who sold all Moses's brothers and sisters to different masters. In his childhood, Moses was the playmate of Billy Grandy's son James, who became his master at a young age. Moses was hired out to Enoch Sawyer to run Sawyer's ferry between Camden and Elizabeth City. Sawyer cruelly sold Moses's wife because he needed some quick money. The couple never saw each other again. During the War of 1812, Moses worked as a blockade runner, moving goods down the Dismal Swamp Canal to Elizabeth City. After the war, he captained a schooner on the Albemarle Sound. Moses worked to purchase his freedom, paying the agreed sum of $600 to his master, James Grandy. But Moses's childhood friend not only withheld his freedom, he sold him to another master. Again, Moses worked to buy his freedom, only to be cheated once more. Finally he was sold to Capt. Edward Minner who allowed him to purchase his freedom. He later bought the freedom of his second wife and children and moved his family to Boston. In 1843, the British and Foreign Anti-slavery Society in Ireland published a biography based on his life, *Narrative of the Life of Moses Grandy, Late a Slave in the United States of America.* He used the proceeds to buy the freedom of other family members. A highway in Chesapeake, Virginia, bears the name Moses Grandy Trail in his honor. (Courtesy of North Carolina Collection, UNC-CH.)

Isaiah Fearing

The patriarch of Elizabeth City's prominent Fearing family, Isaiah Fearing was born in Wareham, Massachusetts. He was educated at Harvard and served aboard an American privateer during the War of 1812. Fearing was captured by a British ship and held prisoner for two years. Upon his release, he became interested in the Dismal Swamp Canal, then being constructed, and settled in Elizabeth City. Fearing established himself as a merchant in town and served as postmaster for six years. His career as Elizabeth City's postmaster ended abruptly. While on a trip to Philadelphia, he mailed his brother a photograph of Pres. Andrew Jackson lying in state. His political enemies discovered this and had him sacked. Fearing had a keen interest in education and brought Thacher Swift down from Harvard to educate his children. Swift is buried in the old Baptist Cemetery. Fearing's son John Bartlett Fearing served as captain, Company 1, 17th North Carolina Volunteers in the Civil War. (Courtesy of Edward Fearing.)

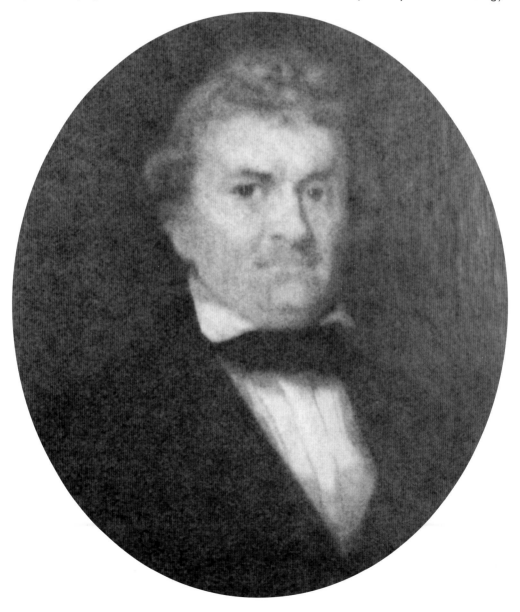

Submit Fearing

The second wife of Isaiah Fearing, Submit Bartlett Fearing, was not nearly as submissive as her name implied. Her son George had an infirmity that kept him from fighting in the Civil War. On February 10, 1862, when Union gunboats sailed up the Pasquotank to attack Elizabeth City, George Fearing was visiting friends living near Knobbs Creek. When the battle began, George and a friend were playing outside. George was struck by Union fire and died in the road. Submit Fearing, receiving word that her son was killed, hitched up her buggy and headed to speak the Union commander. This gentleman received a tongue-lashing from the Massachusetts-born Submit Fearing, and she in turn received a heartfelt apology. (Courtesy of Edward Fearing.)

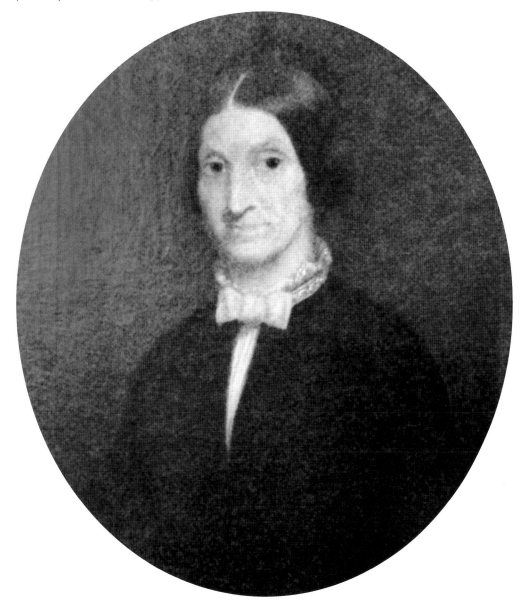

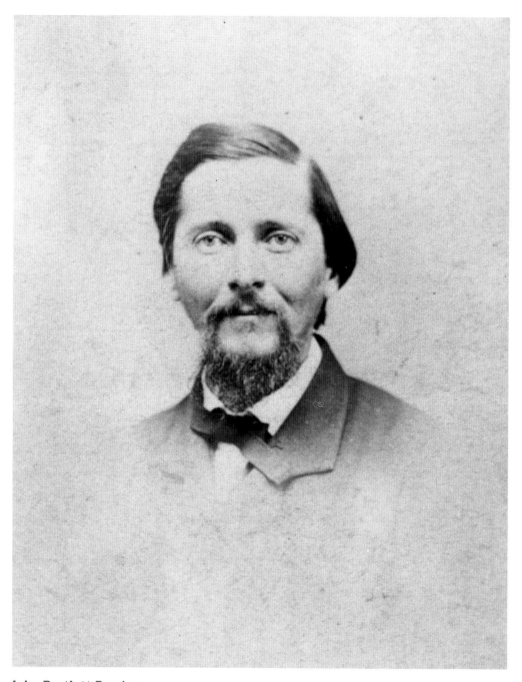

John Bartlett Fearing

John Bartlett Fearing was a son of Isaiah Fearing and Submit Bartlett Fearing. A graduate of Harvard, he operated a general merchandise store at the corner of Road and Church Streets in Elizabeth City. During the Civil War, he served as captain of Company 1, 17th North Carolina Volunteers. In the Battle of Hatteras Inlet, he was captured and spent some time in a Union prison, but he was eventually paroled back to Elizabeth City. He married three times and was the great-grandfather of local historian and Rose Buddy, Fred Fearing. (Courtesy of Museum of the Albemarle.)

Tamsen and Elizabeth Donner

They gave unselfishly, their fortunes and their lives that their children should survive

Near this site, in the winter of 1846, two pioneer women gave up their lives for their families. Tamsen and Elizabeth Donner feared their many children could not survive the ravages of cold and starvation when the party was caught in an early blizzard. They provided care and comfort to their families and companions throughout the snowbound winter, desperately trying to prevent the death of their loved ones. Both lost their lives. However, most of their children survived to carry their mothers' dreams of new life and new beginnings to the valleys of California. The summit that they never crossed now bears their family name.

An inspiration to all who followed their footsteps across the Sierra Nevada Mountains, we herein honor the memory and the sacrifices of these women. Their struggle to survive, enduring hardships we can barely imagine, remains a legacy of the pioneer spirit. On this the 150th anniversary of their tragic encampment the Chief Truckee Chapter of E. Clampus Vitus dedicates this monument to their spirit and the preservation of their memory that we not forget the sacrifices they made in opening California to its destiny.

DEDICATED SEPTEMBER 28, 1996 ECV CHIEF TRUCKEE CHAPTER 3691

Tamsen Donner

One of the most poignant local figures was Tamsen Eustis Donner. A native of Massachusetts, Donner came to Elizabeth City in 1824 to teach at the Elizabeth City Academy. She met Tully Dozier from Camden, and the two were married and had a son. Tragedy struck in 1831 when Donner's husband and son died in an epidemic, and a baby girl was stillborn. Brokenhearted, Donner returned to Massachusetts for a time before moving to Illinois in the 1830s. There, she met and married George Donner, and the couple had three daughters. The Donners decided to relocate to California with several other families in 1846. They made the ill-fated decision to cross the Sierra Nevada Mountains too late in the season and got caught in an early blizzard there. Running out of food, some members of the group resorted to cannibalism. As a rescue party approached, Donner stayed behind with her husband, who was dying of an infection. That decision would seal her fate. When George Donner died, Tamsen Donner walked to the next camp, where she found a member of their group, Louis Keesburg, who was nursing an injured leg. When the rescue party reached the area several days later, there was one survivor: Louis Keesburg. He admitted to cannibalizing Donner's body but insisted that she had died of natural causes. Did Keesburg kill Donner to save himself from starvation? No one will ever know. If Donner's first husband had survived, she would have lived out her life as an ordinary housewife in Camden. Instead, she will forever be connected with the infamous Donner party. (Courtesy of Donner Memorial.)

George Decatur Pool

One of the most prominent families in Elizabeth City's history was the Pool family in the 19th century. Their family seat was a house known as The Eyrie on the Pasquotank River in the southern part of Pasquotank County. The oldest of Solomon and Martha Gaskins Pool's seven children, George Decatur Pool was a farmer, philanthropist, and champion of education. Orphaned in 1832 at age 15, he raised his four brothers and two sisters while taking on responsibility for the vast property holdings that they inherited. George insisted upon extensive education for his six siblings. He married Elizabeth Fletcher and had 10 children of his own. Besides educating his brothers and sisters and his own children, George financed the education of others in the county who had been impoverished by the Civil War. (Courtesy of Museum of the Albemarle.)

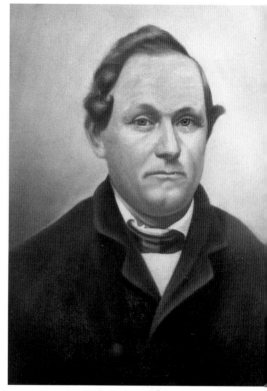

William Gaskins Pool

Brother of George Decatur Pool, William Gaskins Pool was a physician in Pasquotank County. He was the first to build a cottage on the ocean at Nags Head and encouraged other citizens of Pasquotank County to build on oceanfront lots. Some of these early seaside homes still exist, known as "The Unpainted Aristocracy." Dr. Pool's home on Main Street was burned on February 10, 1862, following the Battle of Elizabeth City, along with the Pasquotank County Courthouse and several other structures. Like many prominent locals, Dr. Pool was a Union sympathizer during the war. (Courtesy of Mark Pool.)

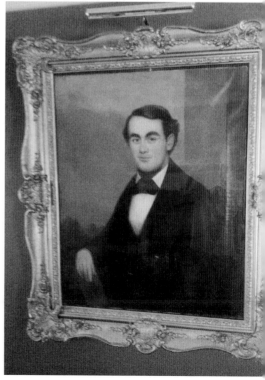

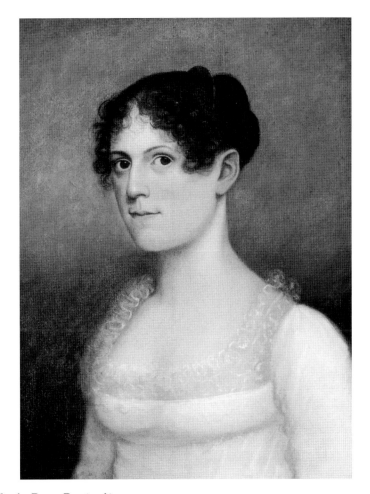

The Theodosia Burr Portrait

In the summer of 1869, Dr. William Gaskins Pool was vacationing at his Nags Head cottage when he was called to the bedside of a fisherman's widow in Nags Head woods. Entering the woman's lowly home, he noticed something grossly out of place; on the wall of the shack hung an oil painting of an aristocratic woman. He immediately recognized it as the work of a master. The elderly widow, a Mrs. Mann, told him this tale: When she was a young girl, "when we were fighting the British," a ship came ashore at Nags Head with sails set and rudder lashed. No one was aboard. Mrs. Mann's sweetheart at the time was one of the local wreckers who boarded and looted the small ship. His share of the spoils included the oil portrait that now hung on her wall. Mrs. Mann gave Dr. Pool the portrait as payment for his services.

After much research, Dr. Pool came to believe that the woman in the portrait was Aaron Burr's daughter, Theodosia Burr Alston. Mrs. Alston had sailed from her home in Georgetown, South Carolina, on December 30, 1812, en route to visit her famous father in New York. Her ship, *The Patriot*, disappeared at sea, and she was never seen again. Was Theodosia carrying a portrait of herself aboard *The Patriot*? This could be the ship that came ashore at Nags Head during the War of 1812. If so, what happened to the passengers remains a question. Various deathbed confessions from former pirates surfaced in the following years. These pirates claimed that they had captured *The Patriot* and made all aboard walk the plank, including an aristocratic young woman. Several of Theodosia's relatives visited Elizabeth City in the 1870s to view the portrait, and proclaimed it a likeness of their kinswoman. Known as the "Nags Head Portrait," the painting now resides in the Louis Walpole Library at Yale University. It has been attributed to famous portrait painter John Vanderlyn. (Courtesy of Horace Walpole Library, Yale University.)

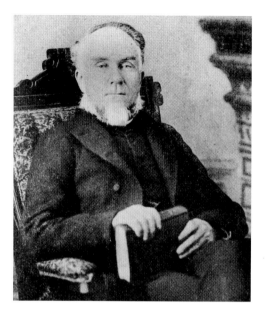

Solomon Pool

Brother of George Decatur Pool, Solomon Pool was president of the University of North Carolina at Chapel Hill from 1869 to 1871. (Courtesy of North Carolina Collection, UNC-CH.)

John Pool

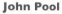

John Pool, brother of George Decatur Pool, was a lawyer and statesman. He was an 1847 graduate of the University of North Carolina at Chapel Hill, and served as state senator in 1856–1860 and in 1864–1866. He served in the US Senate from 1868 to 1873 and practiced law in Washington, DC, until his death in 1884. (Courtesy of Museum of the Albemarle.)

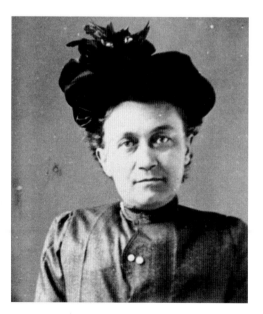

Bettie Freshwater Pool

One of George Decatur Pool's 10 children, Bettie Freshwater Pool was a teacher and author. She wrote several books about local history, including *The Eyrie and Other Stories* and *Literature in the Albemarle*. She also wrote many poems and songs, one of which was North Carolina's state song for a time. As a child, Pool suffered an injury that required her to walk with a cane the rest of her life. She never married. (Courtesy of Museum of the Albemarle.)

The Battle of Elizabeth City

February 10, 1862, was a fateful day in Elizabeth City's history. Two days before, the sounds of battle at Roanoke Island had reverberated across the water to Elizabeth City, the rumble of cannons shaking windows and rattling the nerves of the townspeople. When news came that Roanoke Island had fallen to Union forces, Elizabeth City knew that its own bombardment was imminent. In an effort to defend the town, a fort was hastily set up at Cobb's Point (the site of Culpeper's Rebellion in 1665). Fort Cobb consisted of four cannons manned by eight civilian militiamen. Flag officer William F. Lynch of the Confederate States Navy had six ships at his command with only enough powder for each ship to shoot 10 times. Lynch's navy, known as "The Mosquito Fleet," consisted of a motley collection of civilian tugs and barges that had been converted into warships. The fleet reputedly made up in grit and tenacity what it lacked in firepower. On shore, Col. C.F. Henningsen tried to call out the local militia but, with the exception of the eight men at the fort, no one answered the call; the townspeople had already begun their exodus. Most families gathered their possessions and fled inland, many of them not to return until the war's end. Around 8:30 on the morning of February 10, Union gunboats were sighted coming up the Pasquotank River. Officer Lynch set his ships in a diagonal line downriver of the fort and prepared to defend the town. But the Mosquito Fleet was no match for the 13 well-equipped warships of the Union Navy. The flagship, the CSS *Black Warrior*, was soon disabled. Her crew set her afire and escaped ashore. Her sister ships fared no better. The *Ellis* was captured, and the *Seabird* and the *Fanny* were set on fire and sunk. The *Forrest* was burned as it was being repaired in the shipyard. Only the *Appomattox* escaped and headed up the Dismal Swamp Canal. As for the fort at Cobb Point, the militiamen had deserted their posts there, having discovered that the cannons would not swivel and were useless once the Union fleet sailed past. Henningsen, seeing that no troops would arrive to augment his small force, ordered the town set afire to keep it out of Union hands. Ultimately, only a few blocks of downtown were destroyed, including Dr. William G. Pool's home on the southwest corner of Pool and Main Streets and the wooden courthouse on the site of the present courthouse. By nightfall, Elizabeth City was a dead and deserted town. At midnight, the fires of the town were still burning. The flames of those fires licked the night sky and ushered in the darkest days Elizabeth City would ever know. (Courtesy of Paul McWhorter.)

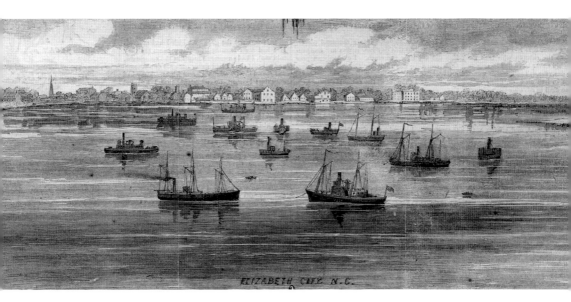

ELIZABETH CITY N.C.

IN MEMORY OF
A GALLANT ACT BY
ARTHUR JONES
WHO SEIZED AND SAVED THE
PASQUOTANK COUNTY
COURTHOUSE RECORDS
BEFORE THE COURTHOUSE
WAS BURNED IN 1862.

Arthur Jones

The Battle of Elizabeth City ended with the downtown area in flames. The Pasquotank County Courthouse was one of the structures set ablaze and was ultimately destroyed. Into this scenario entered an unlikely hero: Arthur Jones. "Colonel" Jones, as he was known, worked at a downtown livery stable. As the flames spread, he took it upon himself to hitch a team to a wagon and head to the courthouse. With flames licking all around him, Jones risked his life to single-handedly remove all the records from the burning courthouse. He transported the records to Parkville at the head of the Little River, where they rode out the war in a friend's barn. Because of Jones's bravery and initiative, these irreplaceable documents, dating back to 1700, survive to this day. If not for this brave act, Arthur Jones's life would probably have gone unmarked. He died a pauper and is buried in the Episcopal Cemetery. He rests next to two unidentified Confederate soldiers in a plot donated by a local citizen. A tale also survives about Jones's wife. Hearing that the battle was lost, she concealed her silver pieces by tying them to her petticoat. Her logic: even a Yankee would be too much of a gentleman to look up a lady's skirt. (Author's collection.)

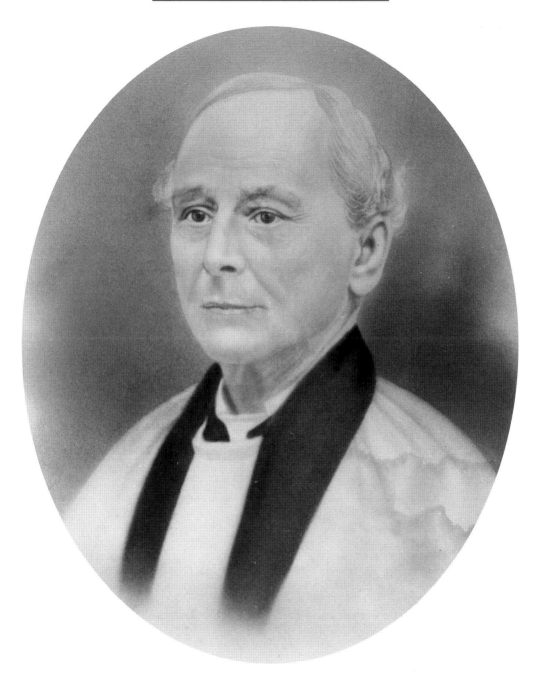

Rev. Edward Forbes
Rev. Edward McCartney Forbes served as rector of Christ Episcopal Church in Elizabeth City for 40 years. He played an important role in the Civil War Battle of Elizabeth City on February 10, 1862. This naval battle on the Pasquotank River was over quickly, with the Union Navy handily defeating the South's Mosquito Fleet. Following the battle, Reverend Forbes donned his vestments and approached the Union naval commander to broker the terms of surrender. Commander Rowan agreed not to burn the town and to treat the inhabitants humanely. Some of the townspeople burned several blocks of downtown to keep the area out of Union hands. (Courtesy of Museum of the Albemarle.)

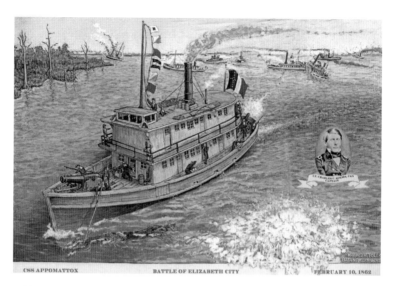

CSS APPOMATTOX BATTLE OF ELIZABETH CITY FEBRUARY 10, 1862

CSS *Appomattox*

All manner of converted civilian ships were used to create a Confederate Navy during the Civil War. A group of converted vessels, known as "The Mosquito Fleet," were used to protect the sounds of northeastern North Carolina. Unfortunately, they were no match for the Union Navy. This was never more apparent than in the Battle of Elizabeth City, which took place on the Pasquotank River. The battle lasted less than 30 minutes, the six vessels of the Mosquito Fleet being no match for the better-equipped 14 vessels of the Union Navy. When it became apparent that all was lost, Lt. Charles Simms of the CSS *Appomattox* ordered his ship to retreat up the Dismal Swamp Canal. The escape was halted when the vessel was found to be two inches too wide to pass through the locks at South Mills. The crew scuttled the ship by setting it afire and swam ashore. Over the years, archeologists attempted to locate the wreck of the small propeller-driven steamer. In 2007, a team of four volunteer divers led by Phillip Madre discovered a sunken vessel in the canal that had many of the specifications of the *Appomattox*, but a positive identification was elusive. Luck was with the team. They brought up a silver-plated spoon from the vessel with the name J. Skerrit engraved upon it. Knowing that the crew of the *Appomattox* was on loan from the Confederate ironclad *Virginia*, Madre checked the *Virginia*'s roster, and there was the name James Skerrit. This clue was enough to tell the team they had found the *Appomattox*. Having spent 145 years in the canal, the wreck of the *Appomattox* is in poor condition and will never be raised, but the team has salvaged the engines and some of its equipment. They and the spoon are now property of the North Carolina Department of Cultural Resources. The painting is by Whiting Toler. Pictured below from left to right are CSS *Appomattox* salvage team members Eddie Congleton, Jason Madre, Jason Forbes, and Philip Madre. (Both, courtesy of Philip Madre.)

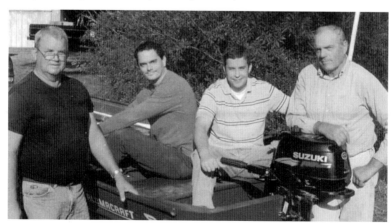

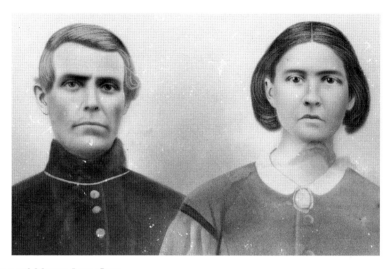

Thad Cox and Mary Ann Cox

Thad Cox was a schoolmaster in the southern part of Pasquotank County who enlisted in the 1st North Carolina Union Volunteers, Company D. After he was promoted to first lieutenant, Cox became aware of threats toward him and his family from guerrilla forces in the area. As his wife prepared to deliver their fourth child, Cox felt the need to transfer his family to Elizabeth City. On February 9, 1863, escorted by four members of his regiment and 10 armed black soldiers, Cox and his family had just set out when they came under attack at Trunk Bridge. A group of guerrilla soldiers had hidden in surrounding Griffin Swamp and behind the unfinished building of St. John's Episcopal Church. They fired at the family, killing Cox, his wife, and their four-year-old daughter, Martha. A rumor began that Cox had held the child in front of him to shield himself from the flying bullets. Richard Benbury Creecy perpetuated this rumor in his book, *Grandfather's Tales*, but Civil War scholars have since proved it to be political propaganda intended to put Cox in a bad light. Cox's horse was so spooked in the attack that it went tearing down the road and was finally reined in at Christopher Hollowell's Bay Side Plantation some three miles away. There, the Hollowells found Cox's seven-year-old daughter, Mary Elizabeth, unharmed in the blood-stained buggy. Another Cox daughter, Robanna, had been a passenger in a following buggy. She remained traumatized by the incident all her life and never lived alone. St. John's Episcopal Church, pictured below, was a half-finished structure that hid several of the guerrilla soldiers who attacked Thad Cox and his family. (Courtesy of Museum of the Albemarle; below, courtesy of Marian Stokes.)

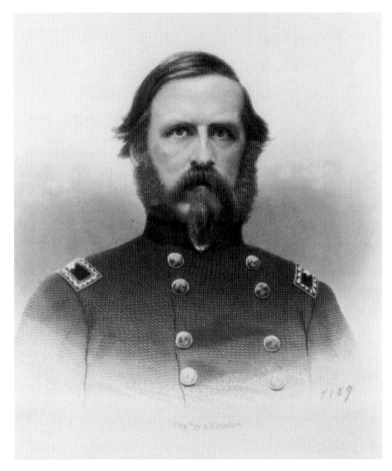

Gen. Edward Wild

By February 1863, the problem of guerrilla forces around Elizabeth City had gotten out of hand. The guerrillas were made up of paroled Confederate soldiers who made attacks on Union sympathizers. The Union's General Butler decided to send in "the devil himself," Brig. Gen. Edward A. Wild, to eradicate the problem. General Wild was a doctor by profession, trained at Harvard. He had participated in the Crimean War in Turkey. Once the Civil War broke out, he joined the First Massachusetts Volunteers. In the Battle of South Mountain, Maryland, his right arm was badly injured and had to be amputated. Legend has it that he calmly instructed the surgeon in the removal of his own arm. The injury ended his career as a physician and left him with a severe phantom pain the rest of his life. Wild's occupation of Elizabeth City lasted seven days—and they were arguably the worst seven days in the town's history. Wild took over Dr. William G. Pool's home on Main Street as his headquarters. His troops proceeded to burn and pillage the homes and holdings of Confederate sympathizers. He freed their slaves, sending the women and children to the Freedmen's Colony on Roanoke Island. The men were recruited for his Colored Troops. The sight of black former slaves bearing arms was a terrifying sight to local residents. Wild continued his outrages by taking two women hostage. They were forced to sleep on a cold stone floor and relieve themselves in public under guard. In a time of chivalry toward women, this treatment was outrageous. During a drum head trial, Wild found one Daniel Bright guilty of being a guerrilla. He had Bright hanged and watched as it took him 20 minutes to die. Asked how he, a healer by profession, could be so callous, Wild replied that he gave no quarter in war. As cruel as it was, Wild's foray into Elizabeth City had the desired effect—the local guerrillas disbanded. (Courtesy of Museum of the Albemarle.)

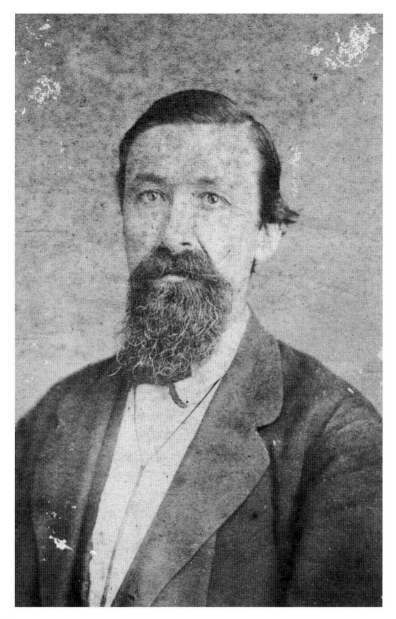

William Dawson

William Crawford Dawson was an artist who became Elizabeth City's first portrait photographer when commercial photography became possible. When the Civil War broke out, he joined the 17th Regiment, Company L, known as the State Guards of Pasquotank. During the war, he sent love letters to his future wife, Nannie White—some of which their descendants still have today. On February 9, 1862, Dawson's regiment was fighting Union troops in the Battle of Roanoke Island when he saw the standard-bearer fall. Dawson rescued the flag and hid it in the lining of his overcoat. He was shipped to a Union prison camp in Currituck and eventually paroled in Elizabeth City. There, he transferred the flag to Nannie White, who concealed it in a feather bed for the duration of the war. The flag's stars were removed and given to descendants of the Dawson family, who still possess them today. (Courtesy of Museum of the Albemarle.)

Flag Canton, State Guards of Pasquotank
Today, the flag's canton resides in the North Carolina Museum of History in Raleigh. (Courtesy of North Carolina Museum of History.)

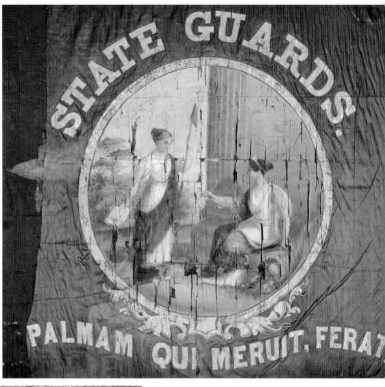

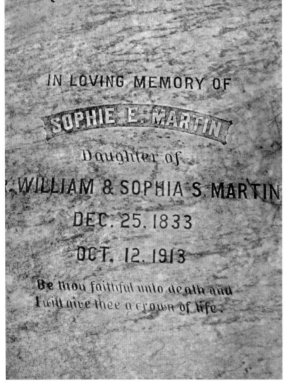

Sophie Martin
Sophie Martin made the battle flag for the North Carolina 17th Regiment, Company L, which William Dawson rescued in battle. Martin opened a school for girls on Church Street after the war. (Author's collection.)

40

Gen. James Martin

Brig. Gen. James Green Martin was the son of Dr. William Martin, Elizabeth City's first physician, as well as a prominent planter and ship builder, who also served in the North Carolina Assembly. His niece was Sophie Martin, who opened a school after the war. James Martin was a career military man who graduated from West Point. While serving in the US Army, he married Marian Murray Read of Delaware, whose great-grandfather George Reed was a signer of the Declaration of Independence. While fighting in the Mexican War, Martin lost an arm and was known thereafter as "One Wing Martin." When the Civil War broke out, he resigned his commission and joined the Confederate Army. As adjutant general for North Carolina, he organized Martin's Brigade, one of the best-drilled and equipped companies in the Confederacy. Martin and his brigade drove back General Pickett's forces in New Bern in 1864. This drew the attention of Robert E. Lee, who assigned him to defend Petersburg, Virginia. In a bitter 10-month siege, Martin's Brigade saved the city of Petersburg from the Yankee invaders, earning a special citation from General Lee. After the war, the once-prosperous Martin family was impoverished. Martin then took up the study of law in Asheville, where he practiced until his death. Martin Street, in downtown Elizabeth City, was named for the Martin family. (Courtesy of Museum of the Albemarle.)

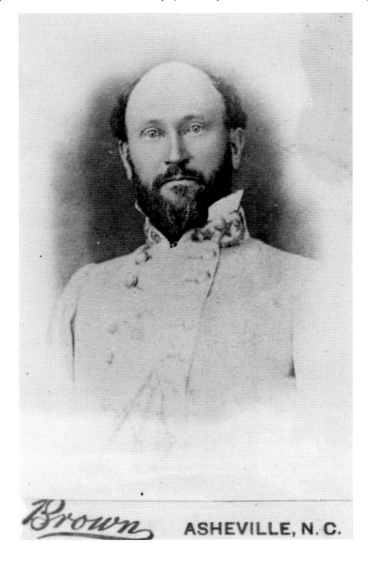

Brown ASHEVILLE, N. C.

Col. William Francis Martin

Another son of Dr. William Martin, William Francis Martin, was the father of schoolteacher Sophie Martin. He attended the University of North Carolina and practiced law in Elizabeth City. During the Civil War, he was a colonel who commanded the 17th Regiment of the North Carolina Volunteers. He was a prisoner of war at Fort Warren in Boston, Massachusetts. After the war, he returned to Elizabeth City, where he continued to practice law and was active in civic life. (Author's collection.)

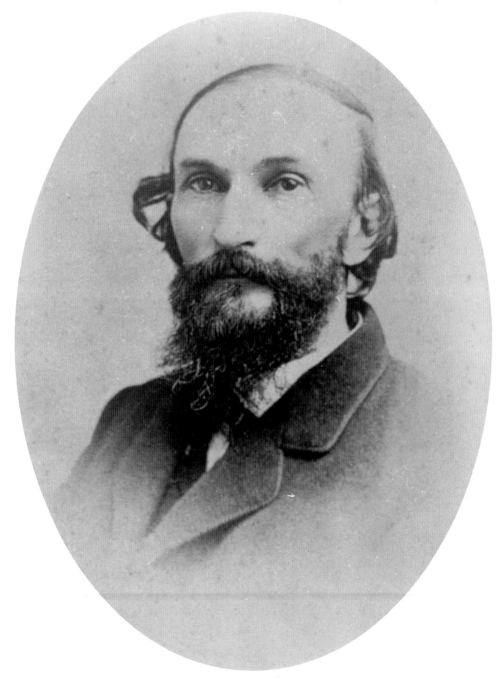

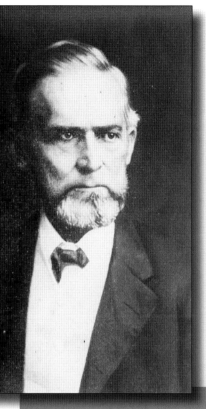

Judge George Brooks

This courageous judge proved the old adage that the pen is mightier than the sword. George W. Brooks was an attorney and prominent citizen of Elizabeth City when the Civil War broke out. Like many prominent local citizens, he wanted to see the Union preserved and did not side with the Confederate cause. However, this stance made him unpopular with most of Elizabeth City's population. After the war, Pres. Andrew Jackson appointed Brooks a US District Court judge. The period following the war was a dark time in North Carolina's history. A corrupt Reconstruction government made life almost intolerable throughout the state. In the summer of 1870, troops occupying Caswell and Alamance Counties began arresting and imprisoning citizens without just cause and denying their right to trial by judge and jury. Into this crisis stepped Judge Brooks. He issued a writ of habeas corpus to have these prisoners brought before him for trial. When Governor Holden refused, President Grant himself ordered that Judge Brook's federal court order be obeyed. At trial, Judge Brooks found the prisoners innocent and released them. Conditions across the state began to improve as a result of this act. With a stroke of the pen, this courageous judge broke the back of the corrupt carpetbag government in North Carolina. Brooks quickly rose from local pariah to statewide hero. (Courtesy of Museum of the Albemarle.)

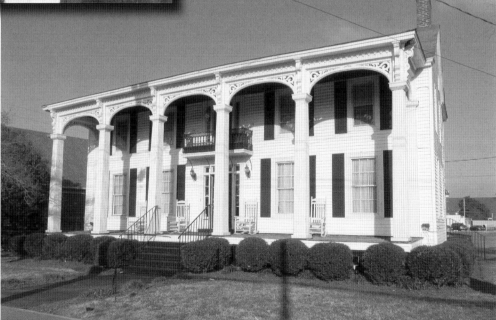

Judge Brooks's Home

Judge Brooks's home still stands near the intersection of South Road and Ehringhaus Streets. It is now occupied by the Rivers Funeral Home. (Author's collection.)

43

Christopher Wilson Hollowell

Christopher Wilson Hollowell came in possession of his plantation in an indirect way. A native of Perquimans County, Hollowell had an elderly cousin in Pasquotank named John Hollowell, who had no heirs. John Hollowell sent for Christopher's older brother to come to Pasquotank and take over his holdings, but the old man was so mean that Christopher's brother soon returned home. Christopher then took his turn and came to Pasquotank. Within a month, the old man died, leaving Christopher Hollowell in possession of his entire estate—755 acres. Christopher Hollowell was a shrewd farmer who implemented improved agricultural methods and owned 2,000 acres at his death. During the Civil War, Hollowell strove to maintain neutrality. Two Union soldiers injured in the Battle of Elizabeth City were taken to Bayside. One of them died and was buried in the Hollowell family cemetery. His sword is still in possession of the Hollowell family. (Courtesy of Museum of the Albemarle.)

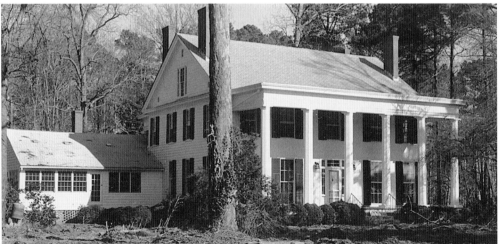

Bay Side Plantation

Bay Side is one of the few Greek Revival plantation houses surviving in Pasquotank County. The family seat of the Hollowells, it is a grand example of antebellum prosperity. The house was built in 1856 by Christopher Wilson Hollowell and remained in the Hollowell family until 1988. Sold at auction, the house was owned for a time by Las Vegas headliner Wayne Newton. Part of the plantation's farmland, about 250 acres, was sold to the Navy in the 1930s to establish a US Coast Guard Air Base. The Hollowell family cemetery was part of that parcel. The gravestones were laid flat and lie adjacent to the airbase's east–west runway. (Courtesy of Museum of the Albemarle.)

Richard Benbury Creecy

The Creecys were originally Huguenots from France who came to the New World seeking religious freedom. A shipwreck cast them ashore on Cape Hatteras in 1647, and their descendants dispersed throughout the Albemarle. By the 1860s, the Creecy family was prominent in Pasquotank County, owning a large plantation in the southern portion.

Richard Benbury Creecy studied law at the University of North Carolina but never practiced. When the Civil War broke out, he faked a broken wrist to be exempted from fighting, though he later expressed regret about his lack of participation. Creecy farmed his large plantation until he took up journalism after the war. Creecy was editor and publisher of the Elizabeth City newspaper the *Economist* from 1870 to 1903. In print, he had an affectation of referring to himself in the third person. He also wrote a book called *Grandfather's Tales of North Carolina History*. He began writing it as a compendium of facts and legends for the edification of his grandchildren. The state of North Carolina funded its publishing, and it was later used as a textbook for North Carolina schoolchildren.

Richard Benbury Creecy's son Richard "Dick" Creecy Jr. was a gifted teacher. He was born into a world of privilege that ended with the Civil War. In the aftermath of the war, the state of education in Elizabeth City was in shambles. Creecy applied himself to the problem, having always wanted to be a teacher. He started a school for boys at his home on Main Street in Elizabeth City. As a teacher, Creecy sought to educate every boy to the extent of the student's ability. He never discriminated or turned down a boy who could not pay. As a result, Creecy was a successful and well-loved educator. In 1954, a group of his former students dedicated a memorial to him at his grave in the Perkins family cemetery in Weeksville. (Courtesy of Museum of the Albemarle.)

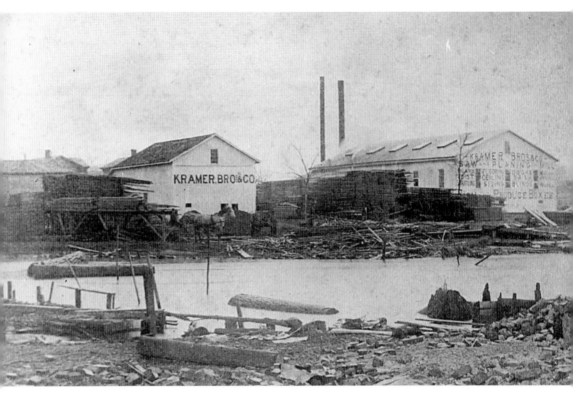

Kramer Brothers Lumber Company

After the Civil War, many northerners saw opportunity in the reconstruction of the South and relocated here to establish businesses. One of these carpetbaggers was Daniel S. Kramer. In 1871, at the age of 36, Kramer moved his wife and six children to Elizabeth City and established a sawing and planing mill. Kramer had been a carpenter in Watsontown, Pennsylvania, who had served briefly in the Union Army. Over a period of 90 years, the D.S. Kramer lumber company would have five name changes before being liquidated in 1961. Kramer's four sons, Ed, John, Joe, and Allan, were partners in the mill, which became known as Kramer Brothers Company.

Kramer Brothers had the first telephone in Elizabeth City. It was a private line that connected the office on Martin Street with the sawmill on Dry Point (Riverside Avenue). Legend has it that a millworker happened to be alone in the office one day when the telephone rang. His nerves were so rattled by the incessant ringing of the newfangled gadget that he picked up the receiver, yelled into it, "There ain't nobody here!" and hung up.

Kramer lumber was used to build homes, stores, and churches all over Elizabeth City as well as providing materials for Orville and Wilbur Wright's flying machine and camp at Kitty Hawk. Kramer-milled doors, windows, and church pews survive today. The business suffered hard times during the Great Depression but rallied to thrive again. Kramer Brothers Company was sold in 1961 to L.R. Foreman and Sons.

Joe Kramer's son Joe Jr. was one of the original Rose Buddies. Along with Fred Fearing, Joe greeted boaters at the waterfront with roses from his own garden. (Courtesy of Museum of the Albemarle.)

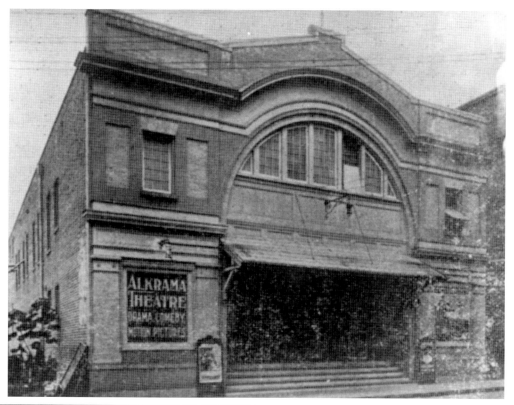

The Alkrama Theatre
Allen Kramer had an entertainment sideline in a moving picture house and vaudeville theater. The Alkrama Theatre opened on McMorrine Street in 1912. (Courtesy of Museum of the Albemarle.)

John Kramer
John Kramer was an attorney in Elizabeth City. He had the misfortune of falling dead in the Pasquotank County Courthouse as he was testifying in a lawsuit against Kramer Brothers. (Courtesy of Museum of the Albemarle.)

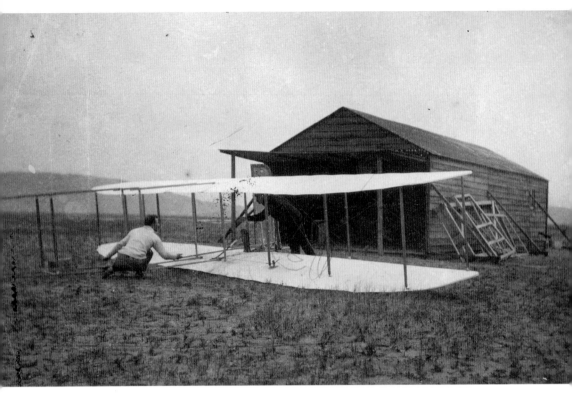

The Kramers and the Wright Brothers

Kramer Brothers' most memorable customers were Orville and Wilbur Wright, without a doubt. On December 18, 1903, Ed Kramer's family sat at the breakfast table discussing a small item in the *North Carolinian*. Reportedly, two bicycle mechanics from Ohio had built a flying machine that had hovered for several seconds over Kill Devil Hill. "Did you ever hear anything as foolish as that?" Ed's wife scoffed. Then Ed reported that two well-dressed young men had come into the Kramer office a couple of weeks before. The salesman could not understand what they wanted, so Ed stepped in and sold the men some lumber. They told him they planned to use it to build a flying machine. "They were right sensible-looking boys, too!" Ed marveled.

The Wright brothers had purchased the lumber to construct their first hangar and camp at Kitty Hawk from Kramer Brothers in 1902. After the successful flight in 1903, they went back to Ohio. When they returned to the camp in 1908, repairs must have been in order: Wilbur's diary for Thursday, April 9, 1908, read, "Bought lumber of Kramer Brothers." The image is from the Alpheus Drinkwater Collection. (Courtesy of East Carolina University.)

Samuel Lloyd "S.L." Sheep

To Daniel Kramer goes the credit for bringing educator Samuel L. Sheep to Elizabeth City. Schools in the area were few and poor following the war, so Kramer lured Sheep here to tutor his children. Sheep started a small school in the Kramer Building on Main Street, teaching the Kramer and Melick children. As Sheep's reputation grew, so did his school, and eventually he became the legendary educator who is remembered today.

The word *education* is synonymous here with Samuel L. "S.L." Sheep, who came to Elizabeth City at the age of 20. Following the Civil War, Elizabeth City residents were desperate for good schooling for their children. Sheep's announcement in 1878 of his intention to establish a school that would accommodate anyone who wished to attend was good news. The Elizabeth City Academy opened on September 2, 1878, with the "latest and most improved normal methods of instruction." The academy was a great success. It later became the Atlantic Collegiate Institute and was attended by students from all over the state. But Sheep was not content with privately educating children; he petitioned tirelessly for free public schools. In 1907, his dream was realized when a public school was established to replace the Atlantic Collegiate Institute. Sheep became the first superintendent of the Elizabeth City Public Schools, a job which he kept until his death in 1928. He served as mentor to a young Hattie N. Harney, another educator who would become legendary in the local school system. After his death, S.L. Sheep Elementary School was named in his honor—a fitting tribute to such a giant of education. (Courtesy of S.L. Sheep Elementary School.)

Hugh Cale

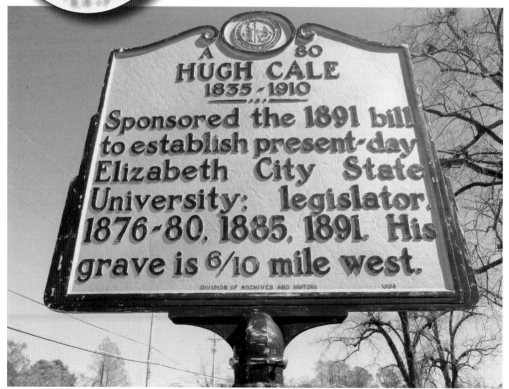

Hugh Cale was a courageous, visionary African American who served in the North Carolina House of Representatives during the tumultuous era of Reconstruction. Cale was born in Perquimans County in 1835. Little is known about his early life, but he is not believed to have been born into slavery. Records show that he had moved to Elizabeth City by 1867. Cale, a Republican, served as Pasquotank County's representative in the state House of Representatives from 1886 to 1880 and again in 1885 and 1891. He was a force of empowerment for blacks, and a unifying element between the races. Cale acknowledged that he could not have been elected without the votes of whites as well as blacks; he was well respected by both groups. A champion of education, Cale had little formal education himself, since only meager schooling was available to him as a child. He saw education as a means of improving one's lot in life. In 1891, Cale introduced House Bill 383 to establish a college in Elizabeth City "for the training and teaching of [black] teachers to teach in the common schools." The Colored Normal School at Elizabeth City opened in January 1892. Today, it is known as Elizabeth City State University, part of the University of North Carolina system. Hugh Cale's legacy endures in Cale Street, the Hugh Cale Community Center, and Cale Dormitory at ECSU, which all bear his name. (Left, courtesy of Elizabeth City State University; below, author's collection.)

HUGH CALE
1835-1910

Sponsored the 1891 bill to establish present-day Elizabeth City State University; legislator, 1876-80, 1885, 1891. His grave is 6/10 mile west.

DIVISION OF ARCHIVES AND HISTORY

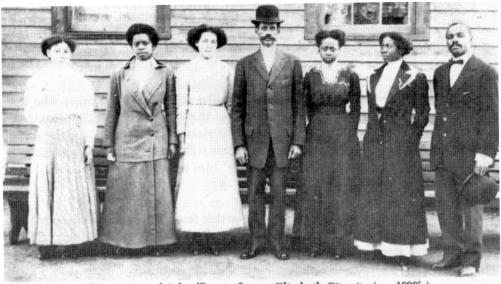

"State Normal School" at its former Elizabeth City site (*ca. 1890's*), Dr. Moore in center.

Peter Weddick "P.W." Moore

If Hugh Cale was the father of Elizabeth City State University, then P.W. Moore was its nurturing force. Born to slave parents in Duplin County, Moore was determined to get an education. He worked his way through Shaw University in Raleigh, earning a bachelor of arts. After teaching for four years in Plymouth, Moore came to Elizabeth City in 1892 to become principal of the new State Normal School for the Colored Race. The college started out with a faculty of two, a budget of $900, and 23 students in a rented building. Moore worked tirelessly to further the fortunes of the fledgling school. Enrollment continued to grow, and in 1894, the school moved to Harrington Road. It moved to its present location in 1912. By the time Moore retired in 1928, he had spent 37 years leading the school from a nebulous idea to a solid reality. When he died in 1934, Mayor Jerome Flora directed all the businesses in town to close for his funeral. Independent editor W.O. Saunders eulogized Moore, calling the school "a silent monument to the quiet strength and influence of a gentle soul." During segregation, P.W. Moore High School was constructed for black students. It continues today as an integrated elementary school. (Above, courtesy of Elizabeth City State University; below, author's collection.)

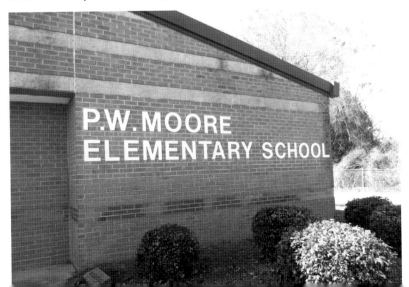

Joseph Sanders

Joseph Foster Sanders was a 19th-century entrepreneur who founded two local businesses that endure today: Sanders Company and the Elizabeth City Ship Yard. Born to an old Weeksville family in 1845, Sanders enlisted in the Union Army during the Civil War. After the war, he opened a blacksmith shop in Weeksville and later had a successful carriage manufacturing business on Poindexter Street. Seeing that automobiles were about to replace buggies as transportation, Sanders quit the carriage business in 1908 and started the Elizabeth City Iron Works and Supply Company, the forerunner of Sanders Company. The first person in Elizabeth City to install running water in his home, he also built the first waterworks in town, supplying running water to the business district. Sanders was joined in business by his three sons from his first marriage, Brad, Henry, and Andrew. Brad's descendant Thorpe Sanders continues to operate Sanders Company today, the fifth generation to do so. (Courtesy of Thorpe Sanders.)

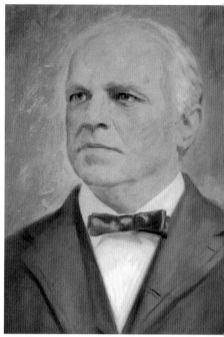

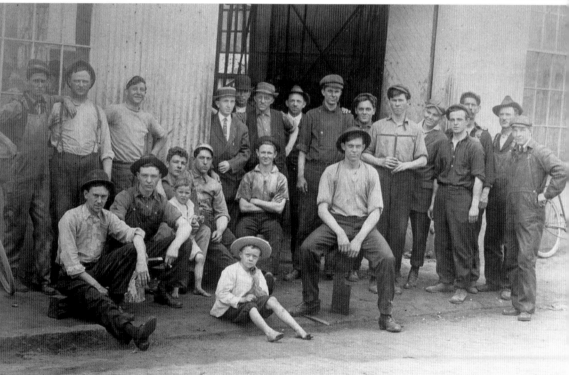

Sanders Company

Sanders Company employees appear in this early-20th-century photograph. (Courtesy of Museum of the Albemarle.)

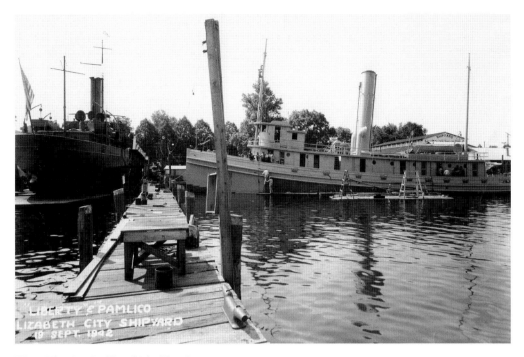

The Elizabeth City Ship Yard

After World War I, the Sanders family bought the Hunter Shipyard on Riverside Avenue, which became the Elizabeth City Ship Yard. It catered to visiting yachts and local commercial boats, including the Texas Company tankers. With the advent of World War II, the shipyard contracted to make wooden submarine chasers for the US Navy. The Elizabeth City Ship Yard set wartime records, building the most sub chasers for the Navy, and constructing them in the fastest time. Joseph Sanders's sons from his second marriage, Archibald and Ernest, ran the shipyard. Ernest, along with New Jersey yachtsman Joel Van Sant, invented the moth boat, a light, fast sailboat that could navigate the shallow waters of the Albemarle area. In 1975, the Sanders family sold the shipyard to the Griffin family, who continue to operate it today. (Courtesy of Marian Stokes.)

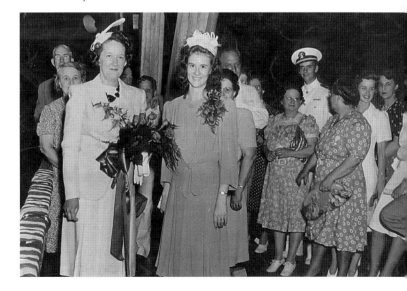

World War II Ship Christening

Mrs. Archie G. Sanders and Mrs. Davis Cartwright preside over a ship christening at the Elizabeth City Ship Yard in June 1943. (Courtesy of Skip Sanders.)

Charles Hall Robinson

Charles Hall Robinson came to Elizabeth City from Jefferson County, New York, in 1868 to look after his father's lumber interests in Pasquotank and Perquimans County. In 1877, he established C.H. Robinson Co., a mercantile firm. This was followed by other successful ventures in retail and wholesale merchandising, textiles, and farming—including the Elizabeth City Hosiery Mill and the Elizabeth City Cotton Mill. C.H. Robinson was one of several businessmen who established the Elizabeth City Cotton Mill in 1895. The cotton mill thrived, at its peak employing as many as 400 workers in round-the-clock shifts. Railroad was the main method of shipping at the time, and the railroad track ran right to the mill's front door. Charles H. Robinson died in 1930 leaving his son Charles Oakley Robinson to run the business. The mill's fortunes increased again with the coming of World War II. After Charles Oakley's death in 1968, his son Charles Oakley "C.O." Robinson Jr. took over operation of the cotton mill. At one point, C.O. had to be away from the mill for a time, leaving a manager in charge. The manager played the futures market with company money and lost it all. Distraught, he committed suicide by shooting himself in the company office. The bullet exited his head and made a hole in the office wall. C.O. left the wall unrepaired to remind himself, and others, never to risk money in the futures market. C.O.'s sons, Charlie and Harry Robinson, were the fourth generation to carry on the business. In 2008, the Elizabeth City Cotton Mill closed after 113 years in business, the textile industry having largely moved overseas. (Courtesy of Charlie and Harry Robinson.)

The Elizabeth City Cotton Mill

Bales of cotton are ready to be carded and spun into thread at the Elizabeth City Cotton Mill in this 1920s photograph. (Courtesy of Charlie and Harry Robinson.)

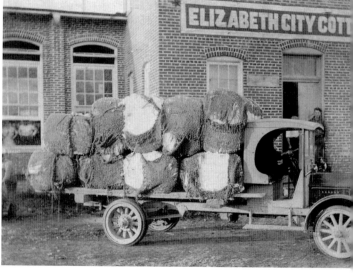

The Foreman Brothers

The Foreman and Blades families in Elizabeth City have long had close ties, both familial and in the lumber business. Clay Foreman and Maria Blades were married in Pike County, Illinois, in 1878. They lived in Nebraska for a time before moving to Elizabeth City in 1892. Maria's brothers James and Lemuel Blades had moved to Elizabeth City in 1888 to start the Elizabeth City Planing Mill, and Clay relocated to become the manager for the mill. In 1893, the Elizabeth City Lumber Company was formed by L.S. Blades, James Blades, Frank Derrikson, and Clay Foreman. This was the first lumber business owned between the Blades and Foreman families. The Foreman Blades Lumber Company followed in 1906. Clay and Maria Foreman had four sons (above, back row, left to right) Wesley, Roscoe, William, and Harold, who all worked in the business. The shares of the Foreman Blades Lumber Company were divided in 1942, and the mill was sold. L. Roscoe continued in the lumber business with his sons, L. Roscoe Jr., Clay, Bob, and Jim, forming L.R. Foreman and Sons in 1947. The company dissolved in 1966. Bob and Jim Foreman continued in the lumber business, forming Foreman Brothers Lumber Company in 1967. After Jim's death in 1976, Bob continued the company before selling it in 1980. (Courtesy of Clay Foreman.)

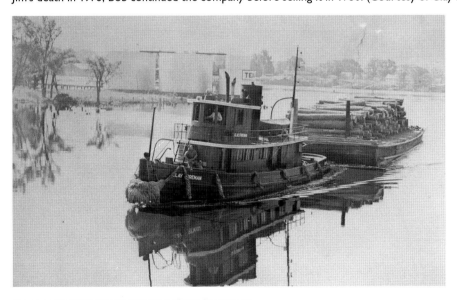

Foreman Mill Tugboat the *Clay Foreman*

The tugboat *Clay Foreman* tows a load of lumber on the Pasquotank River in the early 1900s. (Courtesy of Museum of the Albemarle.)

Miles Jennings

Miles Jennings was owner and operator of Miles Jennings Company from 1896 to 1945. First located on Poindexter Street, the business began as a blacksmith shop, machine shop, and scrap metal yard. Its first building burned to the ground. When the fire began, Roscoe Foreman happened to be passing by and, seeing the flames, raced in and saved the account books. The second location for the business was on Hughes Boulevard. Jennings's son Robert worked with him, and his daughter-in-law Mildred kept the books. Miles Jennings was a good-hearted man who, nonetheless, would curse out anyone who needed cursing. He was generous to a fault with anyone who had done him a good turn and refused to do business with anyone who had done him wrong. He was good to his workers, and no one was in a hurry to go home at the end of the day. More often than not, his employees would sit around the shop and socialize after work until heading home for supper. Robert took over as president of the company when his father passed away and ran it until his own death. Miles Jennings Inc. was relocated to Halstead Boulevard in the 1970s. At this point, the business was mainly a store selling metal parts for machinery. It was sold out of the family in the 1980s. On the opposite page is the Miles Jennings Company in the early 20th century. (Courtesy of Emily White.)

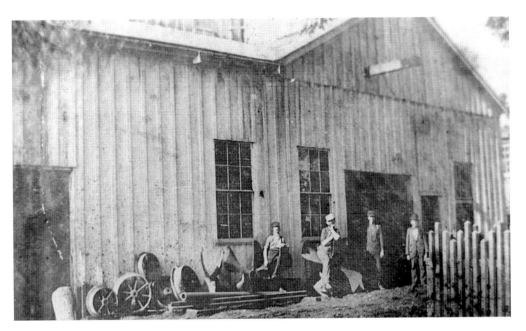

W.H. Weatherly Candy Company

The Weatherly Candy Company was established in 1887 by William Henry Weatherly. He was joined in business by his brother Joe Elwood Weatherly, who ran a wholesale grocery and tobacco establishment. In 1921, the brothers constructed a three-story building at 225 North Water Street. The first story was occupied by the wholesale grocery, the second and third stories were devoted to candy manufacturing. The Weatherly Candy Company specialized in hard candies, especially peanut brittle, which enjoyed a prosperous trade across the United States. For a time, the state of North Carolina had Weatherly's peanut brittle packaged in special boxes featuring the state map. W.H. "Beans" Weatherly Jr. (pictured) holds one of the specially packaged peanut brittle boxes. Weatherly's would also package peanut brittle specifically for Kiwanis International and other civic organizations' fundraisers. Other Weatherly products included Coconut Ice, which was a one-inch cube of coconut hand-dipped in icing. They also produced cinnamon squares and Peach Goodies, whose recipe was copyrighted. It is said that the aroma of Peach Goodies often wafted through the streets of downtown Elizabeth City. The company never produced chocolate candies, having no desire to compete with Hershey's. Weatherly's son W.H. "Beans" Weatherly Jr. and grandson W.H. "Little Beans" Weatherly III followed him into the family business, which operated until 1977. (Both, courtesy of Museum of the Albemarle.)

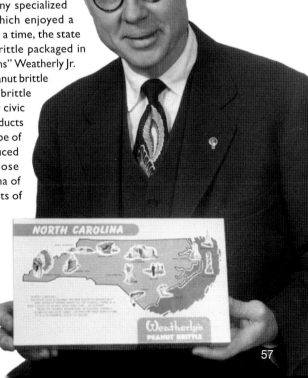

Joe Elwood Weatherly
Elwood Weatherly operated a wholesale grocery and tobacco establishment on the first floor of the building at 225 North Water Street. The business continued through the 1950s. This photograph was taken by J. Howard Stevens. (Courtesy of Museum of the Albemarle.)

W.H. "Little Beans" Weatherly III
Little Beans Weatherly was the third generation to operate the Weatherly Candy Company. (Courtesy of Beans Weatherly.)

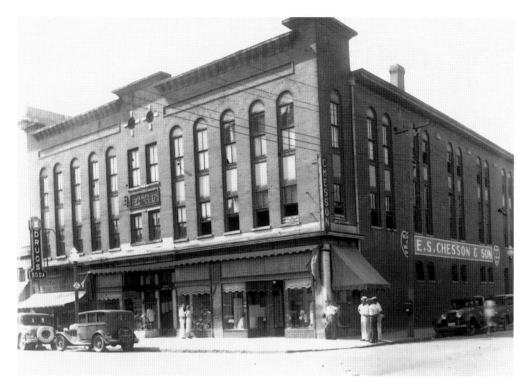

The Lowry-Chesson Building

In 1897, Dr. Freshwater Lowry had a commercial building constructed on the corner of Main and Poindexter Streets. Mitchell's Bee Hive department store occupied the first floor. The Academy of Music shared the second floor with the Improved Order of Red Men and several offices. The Academy of Music, known as "The Opera House," hosted vaudeville productions, as well as graduations and town meetings. Newspaper clippings show that actor Clifton Webb performed here as well as Thomas Mitchell, who portrayed Scarlett O'Hara's father in *Gone with the Wind*. When Nell Cropsey disappeared in 1901, the Opera House was the site of a riotous town meeting. Prominent attorney Edwin F. Aydlett, who defended Jim Wilcox in the Cropsey trial, bought the building in 1900. Aydlett maintained his law office here for many years. Ernest Sinclair Chesson, who opened the E.S. Chesson department store in 1901, bought the building and moved the business here in 1933. A hallmark of the building was the Lamson Cash Carry Conveyor, installed in 1924. The Cash Carry Conveyer ran along the ceiling and was used to send money and sales slips to the building's office on the second floor. It was removed in the 1970s when the building was completely renovated and is now in storage. The building was condemned in 1999 and was set to go under the wrecking ball when ECHNA stepped in. The Elizabeth City Historic Neighborhood Association, a local historic preservation group, raised the money to have the building stabilized then began the search for a buyer. In 2002, the Pasquotank Arts Council bought the building and began renovations. In March of 2007, Arts of the Albemarle (the former Pasquotank Arts Council) moved in to the Lowry-Chesson Building, now known as The Center. Today, the building is a vibrant center for the arts that anchors the downtown area. The first floor is a gleaming art gallery that features local and regional artists. The second-floor theater, now known as the McGuire Theatre, has been renovated and is home to The Center Players children's theater. Classrooms, offices, and a catering kitchen complete the building. The Center is a shining example of what can be achieved when local organizations work together. It is interesting to note what this history-rich site was slated to become: 17 parking spaces. (Courtesy of Marian Stokes.)

Arts of the Albemarle Gallery

Arts of the Albemarle is a regional nonprofit arts council representing Pasquotank, Camden, and Gates Counties. Since 2009, it has been located in the historic Lowry-Chesson Building at 516 East Main Street, now known as The Center. This world-class facility houses gallery space that features over 250 local and regional artists, craftsmen, and photographers, as well as a School of the Arts. The AOA's Center Players, a troupe of award-winning young adult actors in an after-school program, perform three plays a year in The Center's McGuire Theatre, a state-of-the-art, 230-seat performance space occupying a renovated vaudeville theater. The AOA also offers workshops, lectures, and music and dance classes, as well as summer camps for children. (Courtesy of Arts of the Albemarle.)

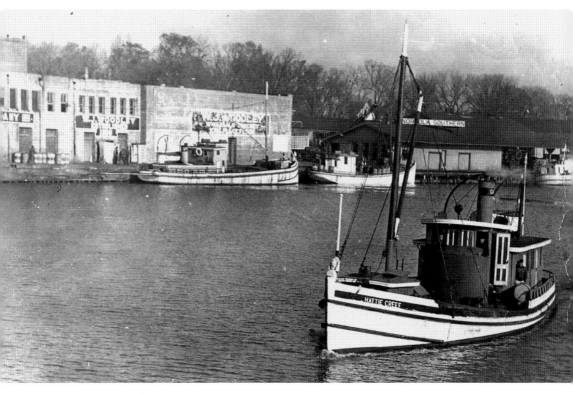

The *Hattie Creef*

The *Hattie Creef* was a little boat with a long history. Built by George Washington Creef of Nags Head in 1888, *Hattie Creef* was born of a shipwreck. A schooner carrying a load of Georgia pine wrecked in a storm off Cape Hatteras in 1887. All hands were lost, but Creef, walking the beach one morning, found the ship's pine cargo littering the shore. He gathered the timber and set to work building a boat of his own design. The 55-foot-long, 18-feet-in-the-beam vessel became the prototype for all the shallow-draft coastal boats that came after it. Creef named the boat after his daughter Hattie and used it as a fishing and oystering boat for a time. Later, it became a passenger vessel, making regular runs up the Pasquotank River to carry passengers and cargo to Nags Head. In 1907, Creef replaced the boat's sail with two engines. Over its long life, the *Hattie Creef* served as a fishing boat, mail boat, tug boat, crabber, passenger boat, and pleasure cruiser on the Dismal Swamp Canal. For a time, it was owned by the Crystal Ice and Coal Company in Elizabeth City. The boat's most famous passengers were Orville and Wilbur Wright, whom it ferried from Elizabeth City to Kitty Hawk several times. In retirement, the *Hattie Creef* was sunk in the Pasquotank River, brought back up, and eventually put on display in Kill Devil Hills. In the 1970s, a businessman bought the boat and moved it next to the Hattie Creef Drive-In in Salvo. There, the *Hattie Creef* met its demise in a fire in the 1980s. The little boat that lived large continues to survive in local lore. (Courtesy of Museum of the Albemarle.)

Orville Wright aboard the *Hattie Creef*
Orville Wright talks with reporters aboard the Hattie Creef in this 1911 photograph that is part of the Alpheus Drinkwater Collection. (Courtesy of East Carolina University.)

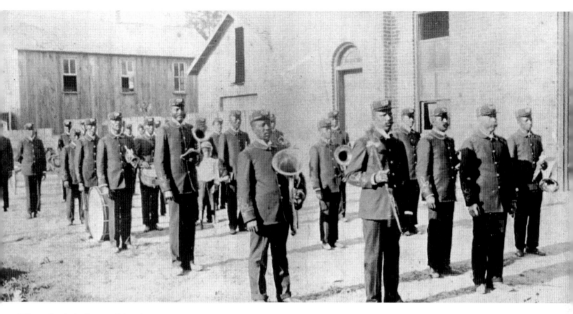

The Quick Step Hook and Ladder Company
The Quick Step Hook and Ladder Company was the first African American firemen's group in Elizabeth City. Organized in 1891, this volunteer fire company operated until it merged with the Elizabeth City Fire Department in the early 1970s. The Quick Step Company was an elite group of men who guarded their membership closely. One of its founders was John Williams, father of Andrew "Salt" Williams. Salt Williams, who passed away in 2012, was the last surviving member of the organization. The Quick Step Hook and Ladder Company formed a marching band, pictured above, which played for various civic functions in the black community. (Courtesy of Marian Stokes.)

Brockway Service Ladder Truck
In the 1920s, the city purchased this Brockway City Service Ladder truck to be manned by the Quick Step Hook and Ladder Company. It was in service until the 1950s. (Courtesy of Museum of the Albemarle.)

Robert Frost and the Great Dismal Swamp

Yes, that Robert Frost. The great American poet who spoke at John F. Kennedy's inauguration once had a run-in with the Great Dismal Swamp, which culminated in a visit to Elizabeth City. The year was 1894 and Frost was 20 years old. He had dropped out of Dartmouth, was unemployed and unpublished. He chose this moment to propose to his sweetheart, Elinor White. Elinor turned him down, probably for the reasons aforementioned. Crushed, he traveled to Deep Creek, Virginia, for the purpose of ending his life in the Great Dismal Swamp. Why he chose the swamp for his demise is unclear. It may have seemed like a suitably gloomy place to end it all and exact revenge for a broken heart. Walking through the swamp, wearing street clothes and carrying a satchel, he would have been an unusual sight. Ten miles into the swamp, he was tired and hungry and began to have second thoughts about ending his young life. He came upon a convivial group of duck hunters from Elizabeth City in a boat on the canal. They invited him aboard and treated him to a night of revelry. As the night progressed, they drank copious amounts of alcohol and began shooting off their guns into the night sky. As the bullets flew through the air erratically, Frost began to fear for the life he had so recently wanted to end. The next day, they reached Elizabeth City and a few days later visited Kitty Hawk. He eventually made it back to his Massachusetts home by train. Frost wrote of the experience in his last collection of poetry, *The Clearing*, when he was in his 80s. The poem was called "Kitty Hawk," and it contained these lines: "I fell in among / Some kind of committee / From Elizabeth City / Each and every one / Loaded with a gun / Or a demijohn / (Need a body ask / If it was a flask?) / Out to kill a duck / Or perhaps a swan / Over Currituck."

The Dismal Swamp episode had a happy ending: Frost got the girl. Elinor White married him the following year. Frost went on to become one of America's greatest poets. (Courtesy of Library of Congress.)

CHAPTER THREE

Growth and Change

The end of the 19th century brought prosperity back to Elizabeth City. The coming of the Norfolk and Southern Railroad opened up the region to the rest of the world and helped commerce to thrive. Businesses established after the Civil War flourished and grew, especially those in the lumber, machine-work, and shipbuilding industries. Many fine homes were constructed in Elizabeth City's downtown during this era to house the families of the growing middle class.

The turn of the century brought to town two bicycle mechanics from Ohio who dreamed of conquering the skies. Elizabeth City was the first leg of Orville and Wilbur Wright's journey to Kitty Hawk. They would travel here by train, then catch a ride on a fishing boat headed to the Outer Banks. The Wright brothers passed through Elizabeth City many times and purchased much of their needed lumber and supplies from local businesses.

In 1901, a murder occurred here that shook the town to its core. Nineteen-year-old Ella Maude "Beautiful Nell" Cropsey disappeared from her father's front porch one November evening. When her lifeless body was pulled from the Pasquotank River a month later, the whole town set its sights on Nell's beau, James Wilcox. His murder trial was the biggest circus the town has ever seen. It jump-started the career of one W.O. Saunders, who would go on to become a nationally known journalist.

A little sailboat with a funny name was born in Elizabeth City in 1929. Local boat builder Ernest Sanders, along with New Jersey yachtsman Joel Van Sant, invented the Moth Boat. This small, light sailboat was designed to easily navigate the shallow waterways of northeastern North Carolina. It soon became an international phenomenon and continues in popularity today. A Moth Boat Regatta is held annually on the Pasquotank River to honor Elizabeth City's contribution to the sailing life.

Elizabeth City's economic golden age continued until the Great Depression in the 1930s, when businesses suffered here as they did all over America. Many of the established family businesses weathered the storm, several of them continuing to operate today. Pres. Franklin Roosevelt visited Elizabeth City in 1939, two years before World War II arrived to bring America out of the Great Depression and usher in the modern age.

A US Coast Guard air base was established on the shores of the Pasquotank River in 1940. The base was commandeered by the Navy during World War II. The war also brought construction of lighter-than-air dirigible hangars adjoining the Coast Guard base. These airships were indispensable in tracking down German U-boats that were destroying United States shipping off the East Coast.

All in all, Elizabeth City rode the fortunes of the early 20th century, adapting and changing with the times.

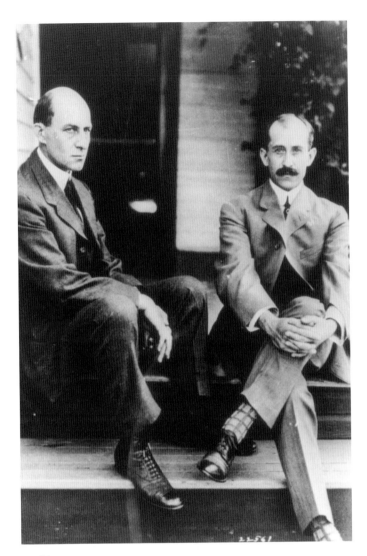

Wilbur and Orville Wright
On September 8, 1900, a young bicycle mechanic named Wilbur Wright arrived in Elizabeth City by train. He checked in at the Arlington Hotel, "where I spent several days waiting for a boat to Kitty Hawk," his journal read. "Nobody seemed to know anything about the place." Three days later, he boarded the *Curlicue*, a schooner captained by Israel Perry, and headed for the Outer Banks. Wright was dismayed by the condition of the boat as well as its captain. "The sails were rotten, the ropes badly worn and the rudderpost half rotted off, and the cabin so dirty and vermin-infested that I kept out of it from first to last." The boat ran into foul weather, and the trip took three days. At times, Wilbur feared they would capsize. "The waves were very high on the bar and broke over the stern very badly," he wrote, adding drily, "Israel had been so long a stranger to the touch of water upon his skin that it affected him very much." Wilbur was also weak from hunger; he refused Captain Perry's food, and consisted on a jar of jam he had brought with him. At last they arrived at Kitty Hawk on September 13. Thus ended the first of many trips to Kitty Hawk, via Elizabeth City, for the Wright brothers. Between 1900 and 1908, Wilbur and Orville Wright would purchase food, building materials, and other supplies from Elizabeth City merchants, including the lumber that constructed their camp and airplane hangar. (Courtesy of Library of Congress.)

Ella Maude "Nell" Cropsey

What would become Elizabeth City's most enduring mystery took place on the night of November 20, 1901. That was the night that beautiful Nell Cropsey disappeared. Nineteen-year-old Ella Maude "Nell" Cropsey had moved to Elizabeth City from Brooklyn, New York, with her family in 1898. Her father, William Cropsey, had seen an ad for a farm to rent in Pasquotank County and moved his wife and nine children to a house on Riverside Avenue. Nell soon took up with Jim Wilcox, the son of Pasquotank County's former sheriff. Jim was a visitor at the Cropsey house that fateful night. His three-year courtship of Nell seemed to be on the rocks. She had ignored him all evening and talked of her upcoming trip to Brooklyn to visit relatives at Thanksgiving. When Jim rose to leave, he told Nell he would like to speak to her out on the porch. Nell walked out on the porch and was never seen again. Jim Wilcox was immediately fingered as the prime suspect in Nell's disappearance. Jim insisted that he had left her crying on the porch. The town was soon up in arms. A town meeting was held at The Academy of Music above Mitchell's Bee Hive department store, and a committee of five was formed to look for Nell. A frantic search began. Bloodhounds were brought in, and the river was dragged. A gypsy clairvoyant named Madame Snell Newman said that Nell's body would be found in a well in Weeksville. All leads led nowhere. Finally, on December 27, Nell's lifeless body was pulled from the Pasquotank River. An autopsy showed that she had died from a blow to the head. Jim Wilcox immediately became the most reviled man in town, though he staunchly maintained his innocence. Jim's trial for Nell's murder was the biggest hoopla the town had ever seen. Jim was found guilty and sentenced to hang, but his lawyer, E.F. Aydlett, got him a mistrial. Tried again in 1903, Jim was sentenced to 30 years in prison. Governor Bucket pardoned him in 1918, and he returned to Elizabeth City. Shunned and reviled, Jim committed suicide in 1933. Before his death, he sat down with the editor of the *Independent*, W.O. Saunders, and told him the truth about

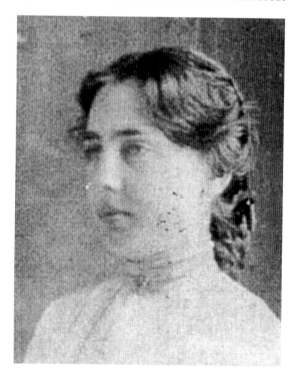

what happened on the night of November 20, 1901. Whatever Jim told him, Saunders took to his death. As the years went by, some interesting facts came out surrounding the case. Of the people at the Cropsey house the night Nell disappeared, three of them ended up committing suicide. Nell's brother Will killed himself in 1908, drinking carbolic acid in front of his wife and child. Nell's sister Ollie's beau, Roy Crawford, died of a self-inflicted gunshot wound in 1911. Ollie herself became an eccentric hermit; until her death in 1940, she continued to dress in the Gibson girl style of 1901—frozen in time in the year of her sister's death. Another intriguing fact later came to light: William Cropsey's ice bill for that cold month of December 1901 was three times its usual amount. Did Nell's father have her body stored on ice somewhere? Her body was amazingly well preserved when pulled from the river. A body in the water that long should have been a feast for fish and crabs. The fact remains that no one knows who killed Nell Cropsey. Most likely, no one ever will. (Courtesy of Marian Stokes.)

Jim Wilcox

When the murdered body of his 19-year-old sweetheart, Ella Maude Cropsey, was discovered on December 27, 1901, Jim Wilcox became the most reviled man in Elizabeth City. Jim was supposedly the last person to see "Nell" Cropsey alive on the evening of November 19, 1901. Jim had visited Nell at her home that evening. They had quarreled, and he insisted later that he had left her crying on her front porch. Jim was arrested for Nell's murder, and a bloodthirsty town condemned him in the court of public opinion. In 1903, a jury found Jim guilty of murder, though there was only circumstantial evidence against him. He served 15 years before Governor Bickett granted him a full pardon in 1918. Jim returned to Elizabeth City where he was ostracized and could not find work. He took his own life in 1933. Many people said Jim's suicide proved his guilt, while others maintained that he had had all he could take of infamy and ill treatment. (Courtesy of Museum of the Albemarle.)

E.F. Aydlett

Edwin Ferebee "E.F." Aydlett was a native of Camden who became a prominent attorney and civic leader in Elizabeth City. Aydlett is best known as Jim Wilcox's defense attorney in his 1902 trial for the murder of Nell Cropsey. This trial attracted great attention, with newspaper reporters from up and down the East Coast in attendance. During the trial, Aydlett shocked everyone—not by something he did, but by something he chose not to do—put Jim Wilcox on the stand in his own defense. A young W.O. Saunders, on his first journalistic assignment, was determined to be the first to file this development. Saunders tied up the only telegraph in town by having the dispatcher transmit a dictionary until he could get his story written. At the conclusion of the trial, Aydlett rose to give his closing statement. At this point, all the spectators in the courtroom stood up and walked out in a prearranged stunt. Aydlett used this shenanigan to get his client a mistrial and represented Wilcox again at his second trial in 1903. Aydlett's law office was located in the Lowry-Chesson building, above Mitchell's Bee Hive Department Store. In 1902, he purchased the building, which is now the home of Arts of the Albemarle. When W.O. Saunders started his own newspaper, the *Independent*, he and Aydlett became bitter enemies, with Saunders often lambasting Aydlett in print. (Courtesy of Danna Bauer.)

William O. "W.O." Saunders

If there ever was a legend in Elizabeth City, it was W.O. Saunders. The editor of Elizabeth City's the *Independent* newspaper, Saunders became known nationwide as a scrappy, confrontational pursuer of the truth. As a teenager working in his father's butcher shop in Hertford, W.O. had a burning desire to be a journalist. His big break came with Jim Wilcox's trial for the murder of Nell Cropsey. When the *Norfolk Dispatch* hired him to cover the trial, 17-year-old Saunders found himself in the big leagues—seated in the press box with reporters from all the major dailies on the East Coast. When he realized Wilcox's lawyer E.F. Aydlett was not going to put Jim on the stand in his own defense, Saunders was determined to scoop the other reporters. He ran to the telegraph office, handed the dispatcher a dictionary and asked him to transmit it. That way, he tied up the only telegraph line in town until he had written his story. Saunders founded the *Independent* in 1908. He used his newspaper to expose graft and corruption and stand up for the little guy. He made many enemies, but he did not care. His desire to seek the truth was stronger than his sense of self preservation. Saunders was sued for libel more than 50 times, but he was never convicted. He eluded a tar-and-feather party and dodged bullets, but he never backed down from his convictions. Saunders would do most anything to make a point. He once walked down Fifth Avenue in New York wearing pajamas to protest men having to wear stiff collars and wool suits in summer. This antic helped bring about a revolution in men's summer business attire. H.L. Mencken once said, "If the South had 40 editors like W.O. Saunders, it would be rid of most of its problems in five years." Saunders was a proponent of most every progressive movement in northeastern North Carolina. He helped make the Wright Brothers monument and *The Lost Colony* outdoor drama a reality. As the years went by, Saunders never forgot about Jim Wilcox. Wilcox's conviction for Nell Cropsey's murder continued to bother him; he had a gut feeling that Wilcox was not guilty. When Wilcox was pardoned and came back to Elizabeth City, Saunders offered him the opportunity to tell his side of the story. One evening in 1933, Wilcox called Saunders to his shabby room and told him what happened the night Nell Cropsey disappeared. He asked Saunders not to tell anyone, and he never did—not even his wife. Saunders took Wilcox's secret to a watery grave. One evening in 1940, Saunders was driving along the Dismal Swamp Canal bank, when he blacked out and plunged his car into the canal. W.O. Saunders drowned at the age of 57. One can only imagine what else the *Independent* man might have done given more time. (Courtesy of Museum of the Albemarle.)

Jennette Brothers

If one spends much time in Elizabeth City, one would see trucks around town sporting the orange and blue logo of Jennette Brothers. This foodservice company has a long history that began over 100 years ago. Brothers Warren and Lawrence Jennette left the family farm in Hyde County and came to Elizabeth City soon after the turn of the century. In 1907, they established Jennette Brothers Company, a farm implement and supply business at 18 Water Street, next to the Weatherly Candy Company. The business grew, adding fertilizer, buggies, and wagons to their inventory. But during the Great Depression, they were forced to downsize. Exiting from the implement business, they became Jennette Fruit and Seed, and moved to Poindexter Street. Lawrence left the company, and Warren was joined in business by four of his sons, Warren Jr., Carter, Bill, and Walton. In the deprivations of the Depression, Warren only had enough money to send one of his children to college. The boys drew straws, and Jack won. He became an attorney and practiced in Elizabeth City for many years. In 1938, the company was renamed Jennette Fruit and Produce and began supplying retail grocery stores. They also started a trucking line that began hauling fruit from Florida. Warren retired in 1949, and Bill and Walton sold their shares to their youngest brother, Bertrand, who brought their cousin Bill McCain into the business. Warren Jr. had left earlier to run the family fishing pier at Nags Head, Jennette's Pier. In 1969, the company moved to the old Crystal Ice and Coal Company tract, next to the Camden bridge where it remains today. The retail produce business declined, and the company became a foodservice business. In 1976, Bill McCain sold his share to Bertrand, who brought in his sons Cully and Carter. The company reincorporated in 1996, returning to its original name, Jennette Brothers. Bert passed away in 2003. His sons Cully and Carter continue to operate Jennette Brothers today as a thriving foodservice company. (Author's collection.)

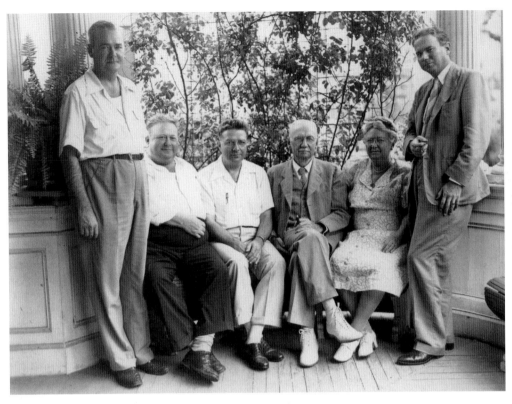

The L.S. Blades Family

The L.S. Blades family is synonymous with the Norfolk and Carolina Telephone and Telegraph Company in Elizabeth City. Organized in 1902, its president Dr. L.S. Blades was joined in business by three of his four sons. Camden Blades served as vice president, James Evans "Fats" Blades was secretary-treasurer, and Lemuel S. Blades Jr. took over as president when his father retired. A fourth son, Melick Blades, moved to Apex and started a chemical company. The Norfolk and Carolina Telephone and Telegraph Company started out with 50 telephones: 40 business lines, 9 residential, and 1 gratis—the Engine House (fire station). Within a year and a half, there were 200 telephones in service. In 1919, a common battery switchboard was installed, phasing out the old crank telephones. By 1923, a basic telephone network existed throughout the Albemarle. Lemuel S. "Lem" Blades III followed his father and grandfather as the third president of the company. Lem Blades was fond of telling a story about working at the telephone company after school when he was a young man. His father informed him one day that the minimum wage had

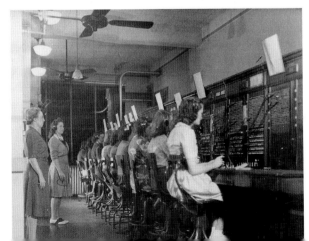

increased, and that his pay would go from 55¢ an hour to 75¢. "Wow," said Lem. "I'm not sure I'm worth that." "You're not," his father replied, "but I've got to pay it anyway!" The company was dissolved in the 1980s. Below, operators monitored by supervisors work the Norfolk and Carolina Telephone and Telegraph Company local switchboard in this 1940s photograph. (Above, courtesy of Carrietta Haskett; right, courtesy of Museum of the Albemarle.)

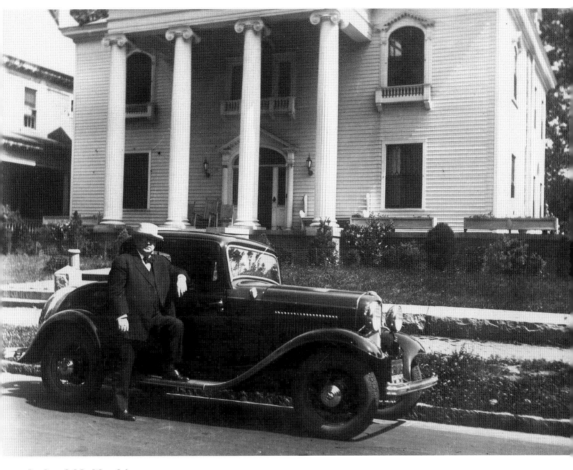

Judge I.M. Meekins

Isaac Melson Meekins was born in Gum Neck, Tyrell County, to a prosperous landowning family. He moved to Elizabeth City in 1896 after graduating from law school at Wake Forest College. He served as both mayor and postmaster during his early years in town, and had a law office on Main Street where Van Johnson's law office is today. Meekins and his wife, Lena, built a large, lavishly detailed Neoclassical Revival–style house at 310 West Main Street. They commissioned an artist to paint scenes of Pompeii on the dining room walls. The Meekins had five children: William, Isabel, Charles, Mary, and Mahala. Tragedy struck when the family traveled to Tyrell County to erect a large obelisk at the grave of Meekins' parents. They were traveling home by ferry when young Charles fell overboard and drowned. A staunch Republican—one of the few in Elizabeth City—Meekins campaigned vigorously for William Howard Taft's bid for the presidency. After his election, President Taft visited the Meekins in Elizabeth City and was entertained overnight at their palatial home. After World War I, Meekins was appointed alien custodian to take care of business connections the enemy had established in the United States. His office was in the Waldorf Astoria in New York City. In 1925, Meekins was appointed to a federal judgeship, a position he held until he retired in 1945. Judge Meekins was a fancy dresser; he always wore a top hat and cutaway coat in public. He never drove a car and instead depended on his daughter Mary or the highway patrol to drive him around. He insisted that his children call him "Father" and not "Daddy." Lena was a talented woman who founded the Elizabeth City Music Club. She was responsible for bringing the Von Trapp Family singers to perform in Elizabeth City. Mrs. Meekins also founded the Daughters of the American Revolution chapter in Elizabeth City and was its first regent. (Courtesy of Museum of the Albemarle.)

Dr. Andrew Pendleton

Dr. Andrew Pendleton was born in 1860 at the historic Pendleton house in the Hall's Creek area of Pasquotank County. He earned his medical degree from Jefferson Medical College in Philadelphia and soon after became the quarantine officer on Dry Tortuga Island. He eventually came back to Elizabeth City and opened the Standard Pharmacy on South Martin Street. At the age of 50, he married 20-year-old Hazel Evans, who was working as a clerk at the New Fowler Store. In the year before their wedding, he wrote her copious love letters that survive in the family today. Hazel always referred to him as "Doctor," and they had a happy union that produced four children. Dr. Pendleton was the first person in Elizabeth City to own a car. One day, he was driving in the middle of the road on the Camden causeway and met another driver doing the same. Stubborn by nature, Dr. Pendleton refused to give way, as did the other driver. A crash resulted that sent Dr. Pendleton's car into one ditch and the other driver's car into the opposite ditch. Dr. Pendleton continued to sit obstinately in the driver's seat as his car was being towed away. Pendleton's most harrowing experience was the amputation of his leg. A diabetic, Pendleton knew he had to have his leg removed, but he could not take anesthesia. He had a special metal trough made at the Elizabeth City Ship Yard. The night before his surgery he placed his leg in the trough and had it packed with ice. By morning, his leg was numb from the ice and was removed with a minimum of pain. He spent the rest of his life in a wheelchair. Pendleton served as postmaster of Elizabeth City for a time and was also president of Guaranty Bank. He passed away in 1951. The Pendletons are here with their children Andrew, Nancy, Hazel, and Frances. (Both, courtesy of Ann Dixon.)

William Henry Zoeller

William Henry Zoeller was a prolific photographer in Elizabeth City for half a century. Zoeller's parents were Bavarian immigrants who settled in Tarboro, North Carolina. He studied photography and came to Elizabeth City in 1890 to work with portrait photographer John Engler, who had a studio here. When Engler retired, Zoeller took over his Main Street studio, renaming it Zoeller's. Over the next 50 years, he photographed almost every man, woman, and child in Elizabeth City. His trademark props were ornate chairs that he had subjects sit in or stand behind. The glass negatives used at the time required several seconds to be exposed, so the subject had to sit very still. Sometimes a head brace would be necessary to keep the subject still. Besides portraiture, Zoeller photographed landmarks and scenery all over the Albemarle, especially the Outer Banks. Most of these he made into postcards. In the 1930s, he was commissioned to take photographs of the Wright Brothers memorial being constructed at Kitty Hawk. Sometimes the wind was blowing so hard over the dunes that he could not keep the camera still. When this happened, he would have people lie down next to the camera's legs to keep it steady. Zoeller also worked for the Eastman-Kodak Company for time, field-testing new chemicals. He died in 1936. (Courtesy of Museum of the Albemarle.)

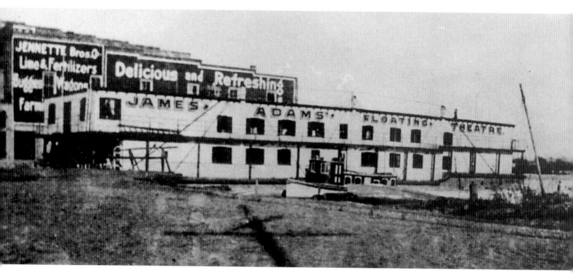

The James Adams Floating Theatre

The James Adams Floating Theatre was a popular vaudeville venue up and down the East Coast in the early 20th century. From February to October, the showboat performed at East Coast ports from Baltimore to Georgia. It wintered over in Elizabeth City every year. Former circus performers James and Gertrude Adams had it built in Bath, North Carolina, in 1913. James Adams's brother Selba and his wife, Clara, joined the showboat's cast and crew as well as James' sister Beulah, who became known as "the Mary Pickford of the Chesapeake." Beulah met Charlie Hunter, production manager, aboard the James Adams Floating Theatre. Beulah and Charlie's courtship inspired the love story in Edna Ferber's book, *Showboat*, which later became a Broadway musical hit and movie. Ferber spent a week aboard the James Adams Floating Theatre doing research for the book. Performer and crew member Pop Neal lived aboard it for 14 years. He passed away one winter and is buried in Elizabeth City's Old Hollywood Cemetery. (Courtesy of Museum of the Albemarle.)

Herbert Peele

In 1911, Herbert Peele founded the *Daily Advance*, which is still published today as Elizabeth City's daily newspaper. In 1947, he started WGAI radio station, which is still on the air. At both *The Daily Advance* and WGAI, Peele featured a daily column called "Peelings." His most amusing columns involved children, such as one little boy in a Baptist church on communion Sunday. The minister called for the deacons to come forward, and the little boy looked around excitedly—expecting the Wake Forest football team to come rushing in. Peele was not a native of the Albemarle area, but he developed a deep love for his adopted region. He supported every progressive movement affecting northeastern North Carolina, including construction of the bridge connecting the Outer Banks to the mainland, the Wright Memorial, *The Lost Colony* outdoor drama, and the air rescue station at the US Coast Guard Base in Weeksville. Peele saw the Albemarle as a vast, sparsely-populated region of great beauty and potential. He increased communication in the area by staffing the *Daily Advance* with full-time correspondents from Windsor to Manteo. For a time, the *Daily Advance* was the only newspaper in the world with a larger reporting staff outside the office than inside. Peele knew that ultimately transportation would be the solution to unifying the Albemarle. He used his newspaper to lobby for highways, bridges, ferries, and air transport. Peele's rival, W.O. Saunders, used his paper, the *Independent*, to achieve the same goals, though the two men were very different. Saunders was a lightning rod for controversy—at times having his life threatened—while Peele was diffident and peaceable, content to be the man that no one recognized on the street. Peele died in 1952. Those living in the Albemarle today enjoy many of the improvements he helped bring about. (Courtesy of Museum of the Albemarle.)

The McPherson Brothers

Oliver, Eddie, and Arthur McPherson were enterprising brothers who worked together to establish some of Elizabeth City's most successful businesses. Oliver, the eldest of 11 children, became the patriarch of the family in 1919 at age 22 when their father passed away. The early years were lean as the siblings continued to work the family farm. In 1924, Arthur and Eddie established McPherson Bus Lines, the first bus line to run between Norfolk and Windsor. In 1927, Oliver, Eddie, and Arthur founded McPherson Brothers auto supply, which continued to operate until 1994. Arthur served as manager and president of the auto supply store until age 72. He was also very active in the Church of Jesus Christ of Latter-day Saints. Oliver, known as "Big Red," weighed over 300 pounds. He loved to go to the movies, and the Carolina Theatre accommodated him by removing two seats and installing a special chair for his use. Eddie obtained the Orange Crush Bottling Company of Elizabeth City in 1933 in partnership with Brother Dallas and sister Alma. They later established the Pepsi plant in Elizabeth City and sold the first Pepsi Cola in 1935. Eddie served as president of the corporation until his death. An active farmer, Eddie founded Eastern Carolina Feed and Seed, installing the first grain elevator on the East Coast. He was also a partner in Elizabeth City Realty, with brothers Oliver and Dallas. Eddie passed away at the Waldorf-Astoria Hotel in New York City while attending a Pepsi Convention in 1960. As a family, the McPhersons were known for their generosity and charity, always reaching out to those less fortunate. Pictured below, Eddie McPherson sits in his office at the Orange Crush plant in the 1930s. (Both, courtesy of Diana Gallop.)

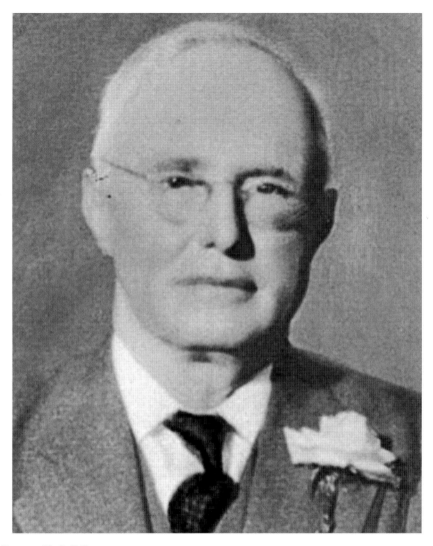

Lord Byron "L.B." Perry
Lord Byron "L.B." Perry was a prolific building contractor who constructed many residences, schools, and commercial buildings in Pasquotank, Chowan, and Perquimans Counties during the Great Depression. Perry was born in Durant's Neck, Perquimans County. His father, Alexis Perry, was an accomplished poet who named his son for his favorite English bard. L.B. Perry moved to Elizabeth City in 1917 where he established the L.B. Perry Motor Company. His son J. Carter Perry soon took over operation of the motor company, leaving L.B. to concentrate on the construction business. Perry Tire Store was later established as an offshoot of the car business. L.B. Perry built several local schools, including Elizabeth City High School, Weeksville High School, and P.W. Moore High School. His most unusual building project was the home he built for George W. Beveridge. Still standing on Riverside Avenue, the Beveridge house is suspended over the Pasquotank River. It is built on piers, and requires a walkway to access it. Members of the Beveridge family were known to have fished from the windows. After the Depression, L.B. and his wife, Sallie, moved to the Outer Banks, where he speculated in real estate. Perry would buy lots for $10, on which he built cottages to be sold. He also constructed the First Colony Inn and the Buchannan cottage, where Pres. Franklin Roosevelt was entertained on his way to *The Lost Colony* outdoor drama in 1939. (Courtesy of Julie Robinson.)

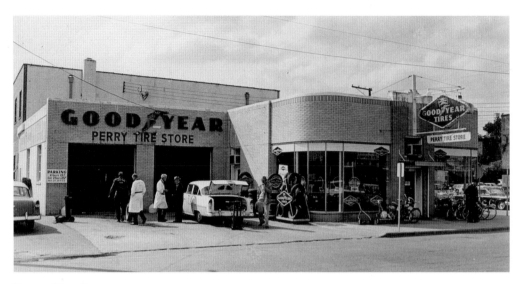

Perry Tire Store
The Perrys established another company, Perry Tire Store, which was an off-shoot of the Perry Motor Company. It came about when the B.F. Goodyear Company insisted on a separate business from which to sell Goodyear tires. L.B. Perry's son Milton operated the tire store, followed by his son-in-law Willis Owens. (Courtesy of Julie Robinson.)

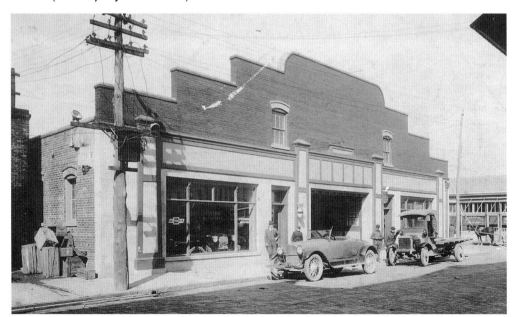

Perry Motor Company
Lord Byron Perry stands to the left of the Chevrolet in this photograph from the 1920s. Perry Motors was located on the corner of Colonial and McMorrine Streets. L.B.'s son J. Carter Perry took over operation of the Perry Motor Company in the 1920s. Carter ran the company until he sold the franchise in 1966. His grandson Wayne Perry reentered the car business, establishing Perry Toyota in the 1970s. Today, Wayne and his son Chris, L.B. Perry's great-great-grandson, continue the family tradition with Perry Auto Group, which includes three Elizabeth City dealerships. (Courtesy of Wayne Perry.)

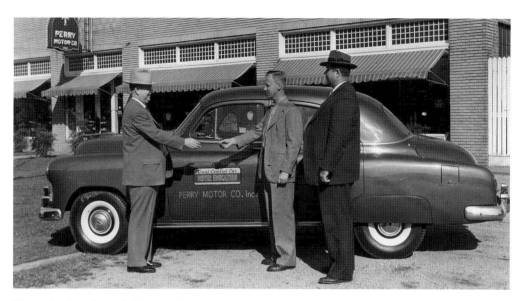

Trannie Crank and Carter Perry
Trannie Crank (middle) is shown here receiving an award from a Chevrolet executive in this 1950s photograph as J. Carter Perry looks on. For many years, Crank purchased the first Chevrolet that came in to Perry Motors' lot every year. If he could not have the first Chevrolet, he would not buy one. (Courtesy of Wayne Perry.)

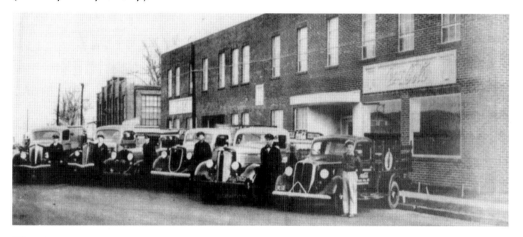

The Dawson Family and Coca-Cola
The Dawson family operated the Coca-Cola Bottling Plant in Elizabeth City for many years. W.C. "Bill" Dawson was the grandson of William Dawson who distinguished himself in the Battle of Roanoke Island during the Civil War, and the grandfather of etiquette maven Nancy Dawson Rascoe. Dawson started out as a bottler of flavored syrups such as sassafras, grape, and strawberry. He also made and sold ice cream. One day, he got a call from Forrest Cathey from Norfolk, Virginia, who had discovered a new syrup flavor and asked if Dawson wanted to try it. When mixed with carbonated water, the new syrup made a drink called Coca-Cola. Cathey sent the syrup from Norfolk to Elizabeth City in barrels on the train. The City Drug Store on Water Street was the first to try out the new flavor. It was, of course, a hit, and Dawson began bottling Coca-Cola in Elizabeth City and distributing it throughout the region. Descendants of W.C. Dawson still continue in the Coca-Cola bottling business today. (Courtesy of Peter Rascoe.)

Harold Overman and Overman and Stevenson Drug Store

Overman and Stevenson Drug Store has been a major presence on Main Street since 1925. John Stevenson began his career in 1913 at the Albemarle Pharmacy, located in the Southern Hotel building on the corner of Road and Main Streets. Harold Overman worked with Dr. Oscar McMullen at the City Drug Store on Water Street. In 1925, the two came together to establish Overman and Stevenson Drug Store. Their first location was in the Mitchell's Bee Hive department store on Main Street. In 1948, the business relocated to the newly renovated Kramer Building next door, where they are still dispensing medicine today. (Above, author's collection; left, courtesy of Museum of the Albemarle.)

Frank Benton

Jim Bridges portrays Frank Benton in the Elizabeth City Historic Ghost Walk, an annual living history event. Benton was a building contractor in Elizabeth City, as well as a colorful local character. At age 15 he ran off with the Barnum and Bailey Circus for a year. As a teenager, he also worked on the James Adams Floating Theatre, which played vaudeville up and down the East Coast. A clever salesman, he would hawk extra-salty popcorn to theater-goers, followed by thirst-quenching Coca-Colas. He also played drums on the floating theater at times. As a young man, Benton worked for local builder Lord Byron Perry and helped build the First Colony Inn at Nags Head in the 1930s. Benton was married briefly to a Lipton Tea heiress and they lived on Panama Street. He seemed to have no hard feelings when she left him, and even attended her second wedding. Something of a ham, Benton would stand on a street corner on Main Street on a Saturday afternoon and commence preaching in a loud voice. People who did not know him would come up and ask him what church he was a pastor for. He always responded with, "Oh, I only have a small following." In his later years, Benton's constant companion was his dog Baalem. Baalem was fond of sitting behind the steering wheel of Benton's truck whenever Benton vacated the driver's seat. He was behind the wheel one day when Benton had parked at the White and Bright supermarket. Benton had left the truck in gear and it began to roll backwards. A woman entered the store exclaiming that a dog was driving a truck! Benton calmly replied, "Darn dog shouldn't be driving. He's only got a learner's permit!" (Author's collection.)

The *Annie L. Vansciver*

The *Annie L. Vansciver* was a ferry steamboat owned by the North River Line in the 1920s and 1930s. On weekdays, the *Vansciver* carried passengers and cargo from Elizabeth City to Currituck. But every Sunday, she became a pleasure boat taking beachgoers to Nags Head. The *Annie L. Vansciver* was built in Philadelphia in 1897 for commercial use. In 1918, she was sold to the Navy and served under the name USS *Samoset*. She was sold back into commercial use after the war, and her original name was restored. In 1922, a group of businessmen in Camden and Currituck saw the potential of having such a vessel to transport produce. They bought the *Annie L. Vansciver* and made Jarvisburg her home port. A trip to Nags Head on the *Vansciver* cost $1.75. She steamed out of Elizabeth City every Sunday at 8:00 a.m. and docked at M.G. Hollowell's wharf at Nags Head. The trip took about four hours each way. Entertainment on board was provided by Flatt's Band, a group of African American musicians led by a fellow called Bob-A-Lee. At 5:00 p.m., the ship's whistle called passengers back on board for the trip home. The Wright Brothers Memorial Bridge, built in 1930, made motor transportation possible to the Outer Banks and heralded the end for the *Annie L. Vansciver*. Her last voyage was in 1934. (Courtesy of Museum of the Albemarle.)

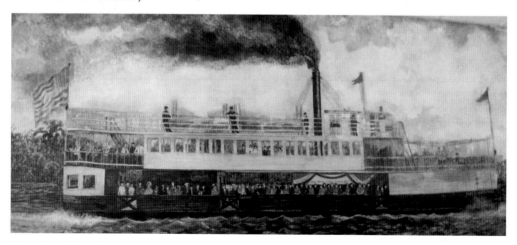

Vansciver Mural

A large mural depicting the *Vansciver* departing for Nags Head covers one wall of the Colonial Restaurant in Elizabeth City. It was painted by Mel Meekins, grandson of the venerable Judge I.M. Meekins. (Author's collection.)

The Moth Boat

In 1929, two sailboat-lovers put their heads together to invent a new class of sailboat: the American Moth Boat. New Jersey resident Joel Van Sant would sail his yacht, *Siesta*, down the Intracoastal Waterway to Florida each year. He was in the habit of putting in for a month at the Elizabeth City Ship Yard to have the *Siesta* overhauled. He and shipyard owner Ernest Sanders became fast friends. On one of these layovers, having time on his hands, Van Sant got the idea of creating a small sailboat that could skim the inland waterways of northeastern North Carolina. He and Sanders collaborated, and together they built the first moth boat. Made of Atlantic white cedar from the Great Dismal Swamp, it was christened the *Jumping Juniper*. The designation "moth boat" came about by accident. Van Sant had painted a butterfly on the sail. A reporter from Norfolk's *Virginian Pilot* remarked, "That looks like a moth. Are you calling it the Moth Boat?" Van Sant liked the sound of it, and the name stuck. A moth boat is defined as a small, fast, singlehanded racing sailboat. It has an 11-foot length, a beam of not more than 6 feet, and a 72-foot area sail. Aside from that there are few restrictions. A moth boat can be a skiff, a dingy, or a prow. The moth boat quickly became a phenomenon. The National Moth Boat Association was formed in 1932, and by 1935 the craft had gained international status. Moth boats have been owned and sailed by such personages as Caroline Kennedy, Martha Stewart, Tipper Gore, and Madonna. Elizabeth City holds an annual moth boat regatta on the Pasquotank River. (Courtesy of Museum of the Albemarle.)

Joel Van Sant
New Jersey yachtsman Joel Van Sant, along with Ernest Sanders, invented the moth boat. (Courtesy of Museum of the Albemarle.)

Moth Boat Regatta
A Moth Boat Regatta is visible here in the 1950s. The regatta is held annually on the Pasquotank River. (Courtesy of Museum of the Albemarle.)

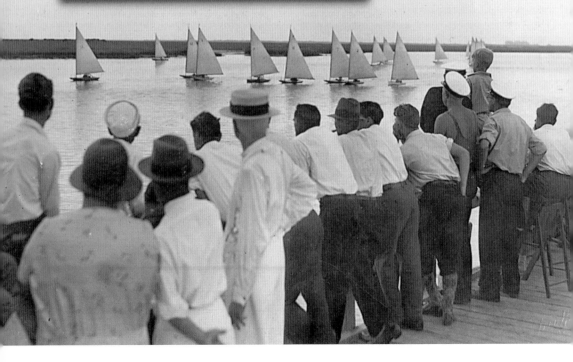

Maj. Al Williams

Alford Joseph Williams was a famed naval aviator who invented dive-bombing and pioneered numerous innovations in flying. Born in the Bronx, New York, in 1896, he was a star athlete at Fordham University. Graduating in 1915, he was signed to pitch for the New York Giants when World War I intruded. Joining the Navy, Williams was drawn to naval aviation and soon found that he was born to be a test pilot. Williams would challenge an airplane to perform to the extent of its ability, while at the same time risking his own neck in death-defying feats. He made an intense study of inverted flying—flying upside down. He loved to fly inverted over corn fields where he would grab handfuls of corn tassels, not winning any points with the local farmers. He got the idea of attaching bombs to the wings of an airplane and aiming directly at a target in a vertical dive. When Williams first presented the idea of dive-bombing to the Bureau of Aeronautics, they dismissed him as a suicidal joy rider. They regretted that response when the Germans developed the same concept in World War II. Williams left the Navy in the 1930s and joined the aviation department of the Gulf Oil Company, where he went on the air-show circuit. That's when he acquired his beloved Gulfhawk II, a German biplane that is now on exhibit at the Smithsonian's National Air and Space Museum. Williams retired in 1951, making his home at The Eyrie on the Pasquotank River. He continued to push the envelope when flying for pleasure. He once flew under the Camden bridge, and in one door and out the other of the massive blimp hangar at Weeksville. Every New Year's Day, he would rise before dawn and fly out to greet the rising sun. Cancer was the cause of his death in 1958, not the fearsome and dangerous feats he attempted in flying machines. The legacy he left to the field of aviation is unparalleled. (Courtesy of Monica Williams.)

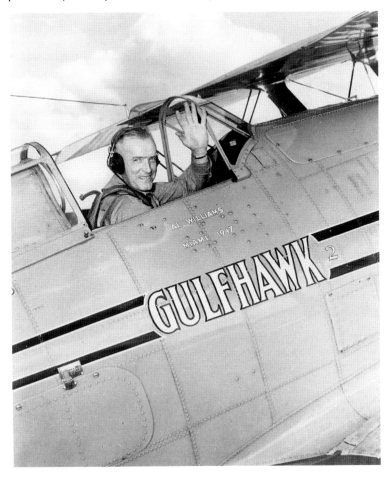

Maudie Fearing

Martha Tillett "Maudie" Fearing showed an indomitable spirit during the crushing hardships of the Great Depression. Her husband, a salesman, died in the early 1930s, leaving her with 10 children to raise on her own. Maudie rose to the occasion, using her innate musical talent to put food on the table. A pianist, she had the uncanny ability to play any tune she heard. Maudie never had a piano lesson—never knew one note from another—but from an early age, there was nothing she could not play. She also taught all her children and grandchildren to play. Maudie played for the silent movies at the Carolina Theatre and the Alkrama Theatre. Sometimes the theater would provide her a libretto, but mostly she made it up as she went along. Maudie also taught dance lessons, though she never had a dancing lesson, and often choreographed routines for local minstrel shows. Asked why she never performed on radio or television, Maudie replied that she never had the money to get to New York City. She was fond of saying, "I've never been anything but poor and happy," insisting that the two states were not mutually exclusive. Maudie and her children put a cheerful face on poverty. Their most memorable Thanksgiving featured a wooden duck decoy on a platter in place of the usual roast turkey; Maudie could not afford a turkey that year, and she knew her children would enjoy the joke. Her ingenuity netted her family a cottage on the Outer Banks. The hurricane of 1933 took the roof off the Hollowell cottage on the sound side at Nags Head, and they sold it to Maudie for a song. Her boys replaced the roof, and the family spent many happy summers there. The outside of the cottage was covered with the nameplates of ships that had wrecked in the area. The cottage is no longer standing, but the ships' nameplates are preserved in the Fearing Collection at the Chicamacomico Lifesaving Station historic site on Hatteras Island. Maudie continued playing the piano until she passed away, well into her 90s. (Courtesy of Diane Drulinger.)

Governor Ehringhaus

Elizabeth City native John Christopher Blucher Ehringhaus served as governor of North Carolina from 1933 to 1937. He was the only resident of Pasquotank County ever to hold the office of governor. Ehringhaus earned a law degree from the University of North Carolina at Chapel Hill in 1902. A lawyer and potato farmer in Elizabeth City, Ehringhaus served in the state legislature from 1905 to 1908. There, he coauthored a bill to create the East Carolina Teachers Training School, now East Carolina University. As governor, he pursued a conservative agenda. He cut state spending and implemented a 3¢ sales tax. He also extended the school year in North Carolina from six months to eight months and kept the schools open and solvent. Though a supporter of President Roosevelt, Governor Ehringhaus was not a fan of the New Deal and limited its impact in North Carolina. Buried in the Episcopal Cemetery, his epitaph reads, "He scorned to take the easy road or compromise; instead he chose the toilsome trail that conscience showed, and did it with a smile." Given that he served during the Great Depression, this was no doubt a fitting epitaph. Ehringhaus dormitory at the University of North Carolina at Chapel Hill is named for Governor Ehringhaus. (Courtesy of Museum of the Albemarle.)

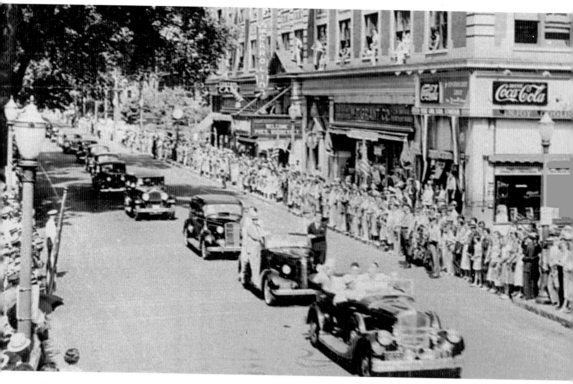

President Roosevelt

On August 18, 1937, Pres. Franklin D. Roosevelt motored through downtown Elizabeth City in an open car as crowds of people lined Main Street. The president had arrived by train early that morning on his way to Roanoke Island. A special performance of *The Lost Colony* outdoor drama was on tap to celebrate the 350th anniversary of the birth of Virginia Dare, the first English child born in the New World. As he rode through town, President Roosevelt was said to have remarked, "I thought that when I came to a town as old as this, I'd see rows of Colonial homes." To which Elizabeth City's mayor Jerome Flora responded, "We had 'em, but you Yankees burned 'em all up!" This exchange may have been apocryphal, but it is fact that Roosevelt boarded a US Coast Guard cutter to the Outer Banks, where he had dinner at tobacco mogul John Buchanan's cottage at Nags Head. Later on Roanoke island, he watched *The Lost Colony* from his car aboard a specially built ramp. "He was clearly impressed," the *New York Times* reported. (Courtesy of Museum of the Albemarle.)

Alvin Sawyer, the Moonshine King

Alvin Sawyer was the most famous moonshiner northeastern North Carolina has ever known—and certainly the most tenacious. Sawyer started making illegal hooch in 1934, and "retired" over 50 years later. Known for making quality moonshine, Sawyer never drank it himself—it was strictly a business venture. He was the bane of area law enforcement officers, who wearily chased him through swamps, fields, and woods. On one raid of Sawyer's home, authorities discovered he had been making moonshine under the floor of his house. They thought they had nailed him, until he excused himself for a moment and jumped out a window. Sawyer did suffer arrest a few times. Hauled before a judge who told him not to make any more moonshine, Sawyer whispered to his lawyer, "I ain't going to make any more of it, but I ain't going to make any less!" Spending four years in a federal prison slowed him down, but not for long. In 1987, authorities caught him running a 2,000-gallon still in a marsh near the Pasquotank River. It holds the record as the biggest moonshine still ever seized in the Dismal Swamp. At this point, at age 69, Sawyer conceded the need to retire from moonshining. Sheriff's deputy Bennie Halstead had been Sawyer's arch nemesis through the years, spending much of his career trying to track him down. Ironically, Sawyer and Halstead spent their golden years living side by side in the same nursing home. They passed the hours reminiscing about the chase. Sawyer's still is on permanent display at the Museum of the Albemarle. (Courtesy of Outer Banks History Center.)

Coast Guard Air Station Elizabeth City

Coast Guard Air Station Elizabeth City was commissioned in August 1940. It had a humble beginning, with four officers, 52 enlisted men, and 10 aircraft. The air station was established on part of the old Hollowell Plantation, Bay Side, which fronted the Pasquotank River. The site was chosen in 1938 because the Pasquotank River was the northernmost ice-free river on the East Coast and because of its strategic value as a potential seaplane base. During World War II, the base came under control of the US Navy, where they conducted search and rescue missions, antisubmarine warfare, and training missions. Coast Guard Air Station Elizabeth City is the largest Coast Guard air station in the United States, conducting missions as far away as Greenland, the Azores, and the Caribbean. In 1966, the air station expanded, absorbing Coast Guard stations in Bermuda and Newfoundland. Today, the Elizabeth City Coast Guard complex includes the Aircraft Repair and Supply Center, Aviation Technical Training Center, Support Center, and Boat Station Elizabeth City. (Author's collection.)

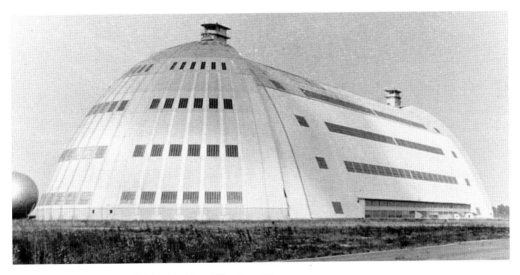

Blimp Hangar, Naval Air Station Weeksville

Constructed in 1941–1942, this is the only remaining steel airship hangar built during World War II. Twenty-stories high, the hangar has the floor area of six football fields. It could contain nine blimps with room to spare. Naval Air Station Weeksville was established in 1941 to service and garage lighter-than-air dirigibles that were used to patrol the coast. German U-boats were wreaking havoc with Allied shipping early in the war. German submarines had sunk 62 merchant ships and claimed thousands of lives in the first four months of 1942. Airships deployed from Air Station Weeksville were highly effective in curbing these losses. An airship crew could see a submarine at shallow depths, and had the means to detect one at deeper levels. Airships had enough fuel to stay in the air for two days and were armed with depth charges and machine guns. With the help of these airships, Allied shipping losses were reduced to zero in 1943. After Weeksville Air Station was decommissioned in 1951, the hangar was used for manufacturing purposes. In 1996, airship manufacturing company TCOM began operations in the hangar, and it has been returned its original purpose. (Courtesy of Museum of the Albemarle.)

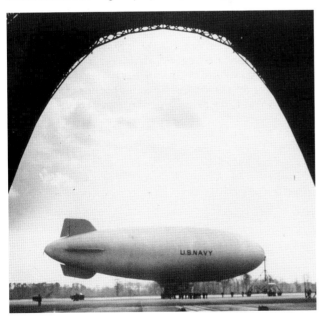

Wooden Blimp Hangar

In 1942, an additional blimp hangar was built adjacent to the first one. This one was made of wood, as metal had been rationed for the war effort. It was the largest wooden building in the world—listed in the Guinness Book of World Records—until August 3, 1995. On that evening, a spark from a welder's torch ignited one of the hangar's massive wooden beams. The resulting fire was uncontrollable, and the building burned to the ground. All that remains today are four stark concrete pillars, reaching 130 feet into the air. (Courtesy of Linda Etheridge.)

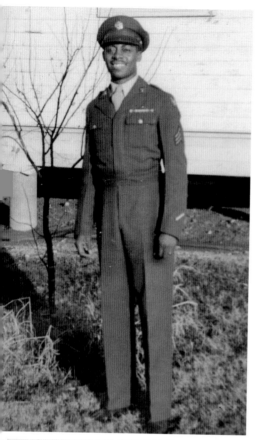

Andrew "Salt" Williams (LEFT AND BELOW LEFT) Andrew "Salt" Williams devoted his life and career to education and the betterment of his community, as well as being part of an historic World War II squadron. A graduate of North Carolina Central University with both bachelor's and master's degrees, Williams also played baseball while in college. When the war broke out, he joined the US Air Force 332nd Fighter Group, being a member of the esteemed all-black Tuskegee Airmen. Williams also played baseball for the Tuskegee Airfield Warhawks baseball team, being a talented third-baseman. After the war, he returned to Elizabeth City, where he taught and coached at P.W. Moore High School, also serving as assistant principal. He was principal at the Annie E. Jones Elementary School in the 1960s before becoming assistant principal at Northeastern High School in 1969. He topped off his career as principal of Central Elementary School and retired in 1983. Williams served on many boards and commissions in the area, always with an eye to promoting racial harmony and improving his beloved Elizabeth City. He received many awards, including the City of Elizabeth City Citizens award. His wife of 64 years, Rubenia Shannon Williams, was also an educator and was an able partner in all of his endeavors. Williams as a Tuskegee Warhawk played third base for the Tuskegee Airfield. (Left, both courtesy of Rubenia Williams.)

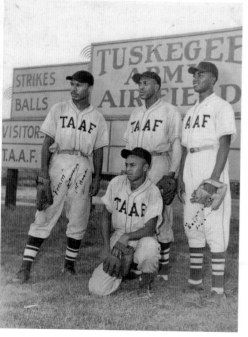

The Albemarle Potato Festival (LEFT)
North Carolina's piedmont is known for tobacco production, but the fertile soil of the Albemarle Sound region has the perfect composition for growing a different crop: Irish potatoes. The Albemarle Potato Festival was born in 1940 to celebrate the potato and its importance to the area's economy. In the early years, the festival was heralded by a motorcade that traveled the 11-county area promoting the event. Beauty queens from each county vied for the title of Potato Queen, and crowds packed Main Street to watch the festival parade. The festival fizzled out in the 1960s and ended in 1970, a victim of changing times. In 2001, the Albemarle Potato Festival was revived by the Albemarle Potato Growers Association and other interested groups. Once again, crowds lined downtown Elizabeth City and the Pasquotank waterfront to celebrate this most important commodity. In 2008, the North Carolina General Assembly enacted a law designating the event as The North Carolina Potato Festival. Today, the festival has returned to the popularity of its early years. The Potato Queen pageant has been replaced by the Little Miss Tater Tot competition for little girls. Over 100 vendors offer food and crafts. There is live music and dancing, a National Potato Peeling Contest, and various culinary cook-offs. Elizabeth City Downtown, Inc., produces The Albemarle Potato Festival annually in mid-May. (Courtesy of Museum of the Albemarle.)

Potato Festival Parade (CENTER)
Elizabeth City High School majorettes clad in potato-sack outfits march down Main Street in this photograph from the 1950s. (Courtesy of Museum of the Albemarle.)

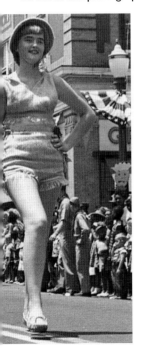

The National Potato Peeling Contest (ABOVE)
Teams vie for the title of potato peeling champion in this 2013 photograph. (Courtesy of Rebecca Cross.)

Harry Umphlett and the Elizabeth City Marriage Chapel

The Elizabeth City Marriage Chapel on Main Street was a legendary institution in Elizabeth City for many years. Justice of the Peace Harry Umphlett was known as "Marrying Sam" to the kids that used to hang out at Hill's Confectionary. Umphlett was justice of the peace in Elizabeth City for nearly four decades. From the 1950s to his death in 1987, he united over 50,000 couples in holy matrimony at the Elizabeth City Marriage Chapel. Umphlett was a barber by profession, who ran the Southern Hotel Barbershop. It was not unusual for him to leave a customer in the chair while he scooted off to perform a wedding. Umphlett married as many as 8 to 10 couples a day—twice as many on Fridays, when the ships came into the Norfolk Navy Base. The Elizabeth City Marriage Chapel was famous in the Tidewater region. Couples could get a quick, legal, and dignified wedding without the 48-hour waiting period required in Virginia. Couples would visit the Pasquotank County Courthouse for a marriage license, then go around the corner to Dr. Zach Owens's office for a quick medical exam. Lab technician Myra Adkins did the blood tests right there in the chapel. If the couple wanted flowers, Anna Lu's Florist was nearby. Witnesses were plentiful—high school students hanging out at Hill's Confectionary next door were always willing to act as witnesses. Umphlett had no set fee for performing marriages; he took whatever the couple wanted to give. If a couple had no money, he would marry them anyway. (Author's collection.)

Robert L. "Bobby" Vaughan

Coach Bobby Vaughan's career at Elizabeth City State University spanned 33 years. Vaughan began coaching basketball in 1949 at Elizabeth City State Teachers College (now ECSU). He was named conference Coach of the Year in 1949, before taking two years off for military service. Returning in 1952, he coached for five more years, racking up 95 victories before being appointed director of athletics. Under his tenure, the university's basketball program thrived, advancing to the playoffs seven times, winning three district championships in the NAIA, and once winning the NCAA Division II South Atlantic Championship. As athletic director, Vaughan expanded the university's athletics from a three-sport program to an 11-sport program, with both men's and women's teams. He was instrumental in the construction and expansion of the university's athletic facilities. The Athletic and Physical Education Center on campus is named the Robert L. Vaughan Center in his honor. He has been inducted into four Halls of Fame and left an enviable legacy behind in the area of athletics. (Courtesy of Marian Stokes.)

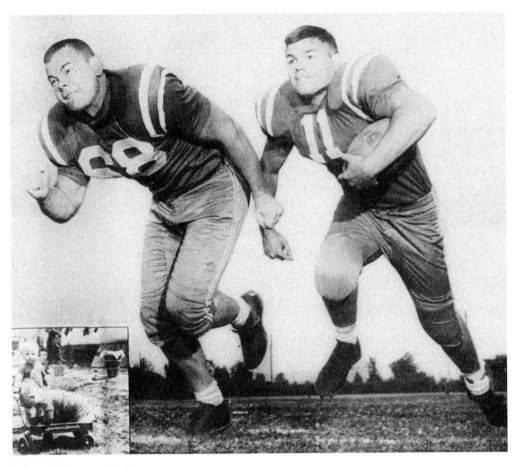

Mike and Jerry McGee

Twin brothers and Elizabeth City natives Mike and Jerry McGee made their mark in the world of sports. The brothers played football for Duke University in the late 1950s. Mike graduated in 1960 as an All-American and ACC Player of the Year. He was awarded the Outland Trophy as the nation's best interior lineman. Mike would go on to play for the St. Louis Cardinals and later became head coach at Duke from 1970 to 1978. Jerry, who graduated in 1961, played in that year's Cotton Bowl against Arkansas. Recovering a fumble late in the game, he was instrumental in the 7-6 win, Duke's last bowl victory to date. Jerry went on to coach at Edenton's Holmes High School, where his team won two state titles. He served in assistant coaching positions at several universities, including Duke. He then coached at Northeastern High School before retiring as athletic director for the Elizabeth City-Pasquotank County School System in 1997. Jerry was recently honored with the Fellowship of Christian Athletes Influence Award for his positive influence on young athletes. (Courtesy of Marian Stokes.)

Paul Winslow

Paul Winslow was the first African American from Pasquotank County to play on a professional football team. Born in Weeksville, Winslow played running back at P.W. Moore High School in the 1950s. He went on to play football at North Carolina Central University in Durham. In 1960, he signed to play for the Green Bay Packers under Vince Lombardi. Winslow was an incredibly fast runner, having the ability to run just as fast backward as forward. Leaving Green Bay in 1961, he went on to play for the Minnesota Vikings, but a knee injury ended his professional career. Winslow then came back to Weeksville and took a job coaching and teaching health and physical education at Union School in Winfall. When Northeastern High School opened in 1969, he began teaching there and coaching both football and track. He retired in 1995. Winslow loved football and loved working with young people. He always went the extra mile to ensure his students' well-being and was ever concerned for their futures. Winslow passed away in 2012. In the team photograph of the 1960 Green Bay Packers below, he is number 23 in the center of the front row. (Both, courtesy of Sarah Winslow.)

Luther "Wimpy" Lassiter

One of the world's greatest pool players was born in Elizabeth City in 1918. Luther "Wimpy" Lassiter was a champion nine-ball player who captured six world championships and many other titles. Lassiter was blessed with incredible eye-hand coordination, which also made him a gifted baseball player. He could have had a career as a pitcher, but the game of pool had a hold on him from childhood. As a boy, he cleaned floors at Elizabeth City Billiards in exchange for practicing endlessly on the pool tables there. He was called "Wimpy" after the character in the Popeye comic strip who loved to eat hamburgers. Lassiter once consumed 12 hot dogs and 13 Cokes and Orange Crushes at one sitting, thus earning himself the nickname. After serving in the Coast Guard during World War II, Lassiter began hustling pool in Norfolk, Virginia. His gracious, Old South manners and innocent countenance tended to disarm his victims. He won a $5,000 jackpot on one game in 1946, a great amount of money at the time. Lassiter won and lost several fortunes over his billiards career. He never married and spent his last years living alone and broke in his childhood home in Elizabeth City. His childhood friend, successful oil distributor Walter Davis, furnished him a stipend to live on. Davis never forgot Lassiter's generosity during their youth, when Lassiter would share with Davis whatever he had. Lassiter died in 1988. (Both, courtesy of Marian Stokes.)

Hattie Harney

Hattie Matthews Harney was truly a legend in Elizabeth City. "Miss Hattie," as she was known, served as an educator for 52 years, first as a teacher, then as a principal. She was a formidable figure who could create compliance in students with just a look. Miss Hattie's students were her whole life, and she cared about every aspect of their education. She created a manual for good behavior called "My Guide Book," which covered such topics as reliability, self-control, thrift, judgment, and good manners. Miss Hattie was also an active member of Christ Episcopal Church. When chaperoning teenage dances in the church parish hall, Miss Hattie kept a sharp eye out for any couple dancing too close together; such behavior was not acceptable. Sheep-Harney Elementary School is named for Hattie Harney and her mentor, educator Samuel L. Sheep. (Courtesy of Museum of the Albemarle.)

Miles Clark

Miles Clark was a wealthy oil distributor for the Texas Oil Company. He is best remembered as the patron of the Elizabeth City High School Band in the 1940s, 1950s, and 1960s. Known to a generation of band students as Uncle Miles, Clark purchased a fleet of five black and gold buses to transport the band to away games and other engagements. Made by the Flxible Clipper company, the buses continued to be used at Northeastern High School until they were decommissioned in 1996. One of the buses was sold to Sony Pictures and appeared in the movie *RV*. Clark also bought the band's uniforms and instruments and sent the group to band camp every summer. He watched with pride as the band performed in Christmas and Potato Festival parades, Oyster Bowl football games, and yearly First Flight celebrations at Kitty Hawk. A true philanthropist, he sent at least one student to college each year, all expenses paid. When he died in 1965, Clark left behind a trust fund for his beloved Elizabeth City High School Band. (Courtesy of Museum of the Albemarle.)

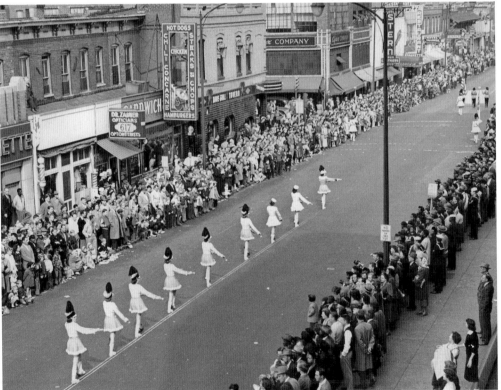

Oyster Bowl Parade
The Elizabeth City High School Band majorettes march down Granby Street in Norfolk, Virginia, in this 1950s photograph. Each year, the band participated in the Norfolk Shrine Club Oyster Bowl Parade and football game. (Courtesy of Museum of the Albemarle.)

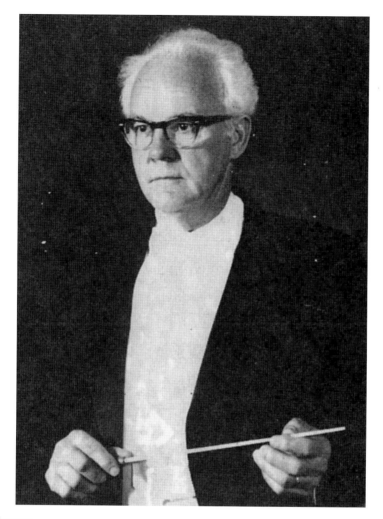

Scott Callaway

"Mr. Callaway" was the high school band director in Elizabeth City for 34 years, first at Elizabeth City High School and later at Northeastern High School. During that time, he touched the lives of hundreds of students. Callaway was born in Oxford, Mississippi, on May 3, 1916, and passed away 93 years later to the day. He majored in music at the University of Mississippi, then served in World War II. While in graduate school at the University of Michigan, he saw something on a bulletin board that changed his life. A high school in Elizabeth City, North Carolina, backed by a wealthy patron, was looking for a band director. Intrigued, Callaway and his wife, Bernice, drove down to check it out. Driving through the gloom of the Dismal Swamp, Bernice was not immediately impressed with area. He got the job and the Callaways happily spent the rest of their lives here. Mr. Callaway wanted the band to participate in as many community events as possible. They played at the Wright Brothers Memorial in Kitty Hawk every December 17th, at the annual ceremony to commemorate flight. They also played at the Norfolk Shrine Club's Oyster Bowl football game every fall. As a band director, Mr. Callaway's subject was music, but his main interest was the student. He was determined that his students would be well-adjusted young people, ready to face whatever life had to offer. As their mentor, he taught them right from wrong and expected them to do their best, both in the band and in life. One of his favorite sayings was, "Always do your dead level best." Many of his students say that Mr. Callaway gave them life lessons that served them long after they left high school. (Courtesy of Museum of the Albemarle.)

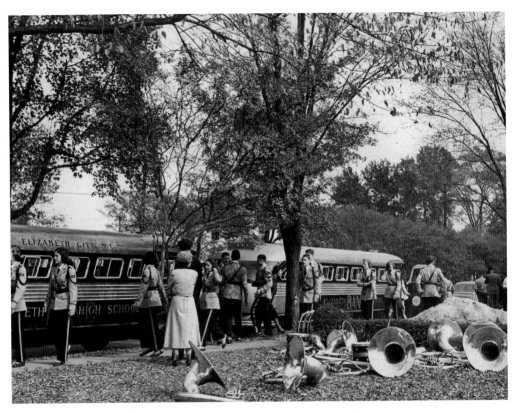

Boarding the Band Buses
Northeastern High School Band members board the buses en route to play at the annual First Flight celebration in Kitty Hawk. Band patron Miles Clark acquired the fleet of Flxible Flyer buses originally for the Elizabeth City High School Band. (Courtesy of Museum of the Albemarle.)

The Poulos Family (OPPOSITE PAGE)
This Greek family brought an enduring restaurant legacy to Elizabeth City. Nicholas Lykiardopoulos was born in 1897 in Cephalonia, Greece, an island in the Ionian Sea. At age 15, he left home to become a cabin boy on an ocean-going ship. The ship dropped him in Philadelphia, and he made his way to New York, even though he spoke no English. After World War I, he came to Elizabeth City and opened the Whitehouse Café in 1924. He married Margaret Koch, the daughter of a German immigrant, and they had six children. In 1939, he became an American citizen and changed his name to Poulos. The Whitehouse Café was a great success, and Nick was forced to change its location several times to accommodate an ever-growing clientele. In 1961, together with sons Bobby and Richard, he built the Colonial Restaurant on Colonial Avenue. His daughters Athene and Angela and daughter-in-law Maxine also worked there. They celebrated Harry's 50th year in business in 1974 with a 1924 menu and 1924 prices. Nick died that year, and sons Bobby and Richard continued to run the Colonial until 1998, when they sold it. Changing hands a couple of times, the restaurant was eventually bought by Warren "Spud" Meads, who had been a faithful customer for years. Today, the Colonial is run by Warren's daughter Lisa and son-in-law Kelly, who have renamed it Spud's Colonial Restaurant. (Courtesy of Museum of the Albemarle and the author's collection.)

Essie Small

"Miss Essie," also known as "Mama Essie" to her grandchildren, was a typical homemaker, mother, and grandmother who loved gardening and playing the piano—until she reached retirement age. In 1962, at the age of 62, she decided to start working outside the home. Her husband, Gaston E. Small Sr., erected a small lunchroom building at his produce dealership G.E. Small and Sons to indulge her love of cooking. Rising at 4 a.m. every day, she served up breakfast to farmers, truck drivers, and laborers. At lunchtime, she offered a different plate special every day, as well as hamburgers and hot dogs. Miss Essie had been legally blind since middle age, but amazingly she could differentiate between a $1 bill and a $20 bill, or any other denomination. At age 84, she retired, arthritis making it too difficult for her to stand. Aside from cooking, her great love was playing the piano. She played like a virtuoso, even though her eyes had been too weak to read music for decades. She instructed her piano-playing grandchildren to "always memorize your music, so you can still play when your eyes go." Miss Essie played piano right up to her death at age 92. (Courtesy of Anita Oldham.)

Walter E. "Stalk" Comstock

Comstock's Confectionary, known colloquially as "Stalk's," was a mainstay of downtown Elizabeth City for 50 years. Walter Comstock opened the Water Street eatery on April 16, 1953, offering 5¢ fountain Cokes. Over the years, Stalk's became famous for its orangeades, milk shakes, and Big Boy burgers—and for the lovely man who ran it. Stalk always had a soft word and a kind smile for everyone. Generous to a fault, he fed many a hungry customer who "couldn't pay right then." Stalk married Lizzie B. Morris, a widow with three children whom he raised as his own. Stalk and Lizzie B. had another child together, Walter Edward Comstock Jr., known as "Ed." Comstock's was very much a family business—Lizzie B. and her mother, "Grandmaw Ginny" Whidbee, whipped up the homemade chicken salad, pimento cheese, and ham salad for Stalk's sandwiches. Ed's wife Norma worked in the store for 10 years. Stalk himself had an uncanny knack for figures. He always added up a customer's total in his head, never using a calculator. A visit to Stalk's was like being in a time capsule. The walls were covered with old photographs and memorabilia that customers brought in. Stalk's love for the UNC Tar Heels was also apparent, with Carolina ephemera displayed throughout the store. Stalk retired and closed the store on April 16, 2003, fifty years to the day after it opened. The art deco counter and sandwich sign from Comstock's are on permanent display in the Museum of the Albemarle. Stalk and his son Ed were both recipients of The Order of the Long Leaf Pine, the highest civilian honor bestowed on a North Carolinian. (Courtesy of Ed Comstock.)

Melvin Daniels Jr.

A scion of an old Outer Banks family, Melvin Daniels left his home in Wanchese and moved to Elizabeth City, where he married Gladys Toxey and had a career in banking. He served as a North Carolina state senator from 1975 to 1985, during which he instigated and saw passage of a number of laws that greatly benefitted northeastern North Carolina. Daniels supported the fledgling Museum of the Albemarle in its early years. He engineered passage of a bill through the general assembly, which funded the yearly operations of the museum and guaranteed that it would stay open. Another bill he initiated was the Historic Albemarle Tour—the first self-guided driving tour in North Carolina. He promoted the idea that tourism and history were as important as commerce in the Albemarle. He also wrote and saw passage of funding for Jockey's Ridge State Park at Nags Head, "First in Flight" North Carolina license plates, the four-lane implementation of Highway 17 to the Virginia line, and the establishment of a graduate and continuing education center at Elizabeth City State University. Daniels's ancestors came to Roanoke Island in 1736. His father, Melvin Daniels Sr., and his famous cousin, Josephus Daniels, started the tradition of "Daniels Day" in 1934. More than a family reunion, Daniel's Day features prestigious speakers and hundreds of guests. It takes place each year in Wanchese. Josephus Daniels made a name for himself as secretary of the Navy under Woodrow Wilson and later bought the *Raleigh News & Observer*. Melvin Daniels Jr. passed away in 2011 at the age of 88. He was instrumental in bringing prosperity to northeastern North Carolina during his term of service in the North Carolina Senate. The Melvin Daniels Bridge that connects Nags Head to the Manteo causeway is named in his honor. (Courtesy of Roy Daniels.)

Daniels and President Roosevelt
On August 18, 1937, Pres. Franklin D. Roosevelt visited Roanoke Island to see a performance of *The Lost Colony*. As young Melvin Daniels and his friends stood near the president's car, a Secret Service agent approached and asked, "Which one of you is Daniels?" Five boys raised their hands in response. Young Melvin was singled out and approached the president's car. North Carolina first district Rep. Lindsey Warren introduced him to President Roosevelt, saying, "Mr. President, I want you to meet the best checker player on Roanoke Island." In later years, Daniels recalled being very impressed by the president's car. (Courtesy of North Carolina Collection, UNC-CH.)

Lucy Vaughan

Lucy Vaughan was a College of the Albemarle instructor who taught drama, speech, and diction there for 30 years. Before becoming a teacher, Vaughan had an unbelievably glamorous past in show business. A native of Texas, she moved to New York City prior to World War II and appeared as a chorus girl in the musical *Best Foot Forward*. While in New York, she made many famous friends, including Lauren Bacall and Red Skelton. For a time, Vaughan dated Frank Sinatra, whom she met at a party. When the war broke out, she joined the USO as an entertainer and headed to Europe. While stationed in France, she shared a room with a then unknown Ingrid Berman. After the war, Vaughan drifted around singing in nightclubs. One snowy night in Cleveland, her life changed forever. A drunken nightclub owner forced her into his car. They skidded off the road and had a terrible accident. Vaughan's right foot was crushed, and her career as an entertainer was over. Doctors told her that her foot would have to be fused permanently in one position. Vaughan instructed them to fuse her foot with the heel up, so she could continue wearing her beloved high heel shoes. After the accident, she went to college and eventually earned a master's degree in theatre arts. She came to Elizabeth City in 1964 to start the theater program at COA. She also branched out to participate in community theater. The title of Vaughan's first musical was indicative of the way she lived her life. She always put her best foot forward—and it was wearing a high heel. (Courtesy of William Sterritt.)

Walter Davis

Walter Royal Davis is a prime example of what a person can achieve with vision, determination, and hard work. Davis was born on a Pasquotank County farm in 1920. Rebellious and independent, he had been expelled by three high schools before his parents sent him to Hargrave Military Academy in Virginia to complete his education. He came back to Elizabeth City and worked as a clerk in a chain store before joining the McLean Trucking Company as a long-distance driver. A conversation with another driver in California led him to Texas. Oil producers there in the Permian Basin were having trouble getting their oil to refineries. Davis borrowed $1,000, bought five trucks, and started a trucking business called Permian Oil, which transported crude oil from wells to refineries. The oil business grew, and Davis's fortunes grew along with it. In 1966, Permian Oil merged with a major oil company, Occidental Petroleum Corporation. There, Davis was the top executive after CEO Armand Hammer. He left Occidental after a few years and started another company. Davis was generous with his wealth, becoming a major philanthropist and champion of education. He served as a trustee of both Duke University and the University of North Carolina at Chapel Hill. An avid Tar Heel, Davis contributed $1 million toward construction of the Dean Smith Center at UNC-Chapel Hill, and $1.4 million to the campus library that bears his name, the Walter Royal Davis Library. In his hometown, he endowed the Walter R. Davis School of Business and Economics at Elizabeth City State University. Though Davis never went to college, he believed in the power of higher education. Over the years, he paid for the college educations of more than 1,300 people. He was known for his spontaneous generosity, sometimes tipping waitresses as much as $1,000. Davis also never forgot the generosity of others; his childhood friend Luther "Wimpy" Lassiter had always shared with Davis whatever he had. Davis reciprocated by supporting the champion pool player in his later years when Lassiter had lost all his fortune. Davis was married six times—twice to the same woman—and had one child. He died in 2008, leaving behind a legacy that will long endure. (Courtesy of North Carolina Collection, UNC-CH.)

Wittier Crockett "W.C." Witherspoon
"W.C." Witherspoon was truly a gentleman and a scholar. He served five terms on the Pasquotank County Board of Commissioners and helped bring unity to the group. An educator by profession, Witherspoon was principal of a segregated school in Camden for many years. He believed in training the whole child, not just the child's mind. He was determined that his students behave as ladies and gentlemen, teaching them etiquette, hospitality, and honesty, along with the three Rs. He lived as an example of what he taught—he always wore a tie, even at home working in his garden. When elected to the Pasquotank County Board of Commissioners in 1987, Witherspoon was the only black member in the board's 300-year history. With his calming presence and ability to soothe hard feelings, he helped assure that the board members would all work together and get along. One of the board's more colorful members, he was fond of quoting Shakespeare in meetings to get a point across. Witherspoon devoted his life to improving interracial relations in Elizabeth City. Along with white-clothing-store-owner Cader Harris, he formed The Hope Group in 1992. The two men were seeking a way to ease racial tensions locally following the Los Angeles race riots. They got whites and blacks to sit down together and talk about divisive issues. They spoke at civic meetings and churches in an effort to promote harmony. The friendship between the two men set a good example. Witherspoon was not immune to criticism, however. There were blacks who considered him an "Uncle Tom," as there were whites who considered his intellectualism "uppity." Witherspoon remained unmoved. "I don't choose the 'black' way or the 'white' way," he said, "I only choose the right way." When the Pasquotank-Camden Library was moved to its present location on Colonial Avenue, it was renamed the W.C. Witherspoon Library in his memory and honor. (Courtesy of W.C. Witherspoon Library.)

Chief W.C. Owens

Chief Owens was a revered figure in Elizabeth City, serving as the city's police chief for 46 years. Owens joined the police department in 1941 and attained the office of chief in 1947. He trained at the Institute of Government at Chapel Hill under instructor Terry Sanford, and he attended the FBI Academy at Quantico, Virginia. Owens seldom pulled or fired a gun, preferring to talk out a suspect, as he did the Freezer Locker murderer in the mid-1950s. In an early example of a mass public shooting, a gunman burst into the Freezer Locker meat market on Grice Street and opened fire. Three people were killed and two injured. Chief Owens and Sheriff Leslie Thompson managed to talk out the shooter and take him into custody. Many of Owens's cases were written up in detective magazines, a popular genre in the 1940s and 1950s. The police force under Chief Owens was a very close-knit group, like an extended family. Owens himself was a workaholic, who took only four days off the entire 46 years he served. His son Bill drove him to Florida once, hoping to give him a vacation. Reaching Florida, Owens immediately jumped on an airplane, came back to Elizabeth City, and went back to work. When he accrued 430 vacation days, the city tried to give him a check for the unused time; he refused to take it. Owens enjoyed photography as a hobby. He took hundreds of pictures of civic events, political events, and crime scenes. He developed them himself in the police station darkroom. Owens demonstrated time and again that he always had the public's best interest at heart. The Tri-County Jail was funded by a grant that he secured. When he retired in 1992, Owens had set a record as the longest-serving police chief in the nation who had served in one town. (Courtesy of Bill Owens.)

Fred Fearing

Fred Fearing was a legend in his own time. A descendant of Isaiah Fearing, who moved to Elizabeth City soon after the War of 1812, Fearing was born in the old Grice-Fearing home on the corner of Road and Fearing Streets. A talented center-fielder, he won a baseball scholarship to Louisburg College in 1933. On the second day of orientation at Louisburg, he met the love of his life, Florence Alston. Fred and Florence married in 1936 and settled in Elizabeth City, where Fearing worked for the post office for 34 years. The couple had two children, Fred A. and Pat. In his later years, Fearing was known as the unofficial town historian of Elizabeth City. Even in his 90s, he displayed an encyclopedic knowledge of local people and historic events. Some historic figures and events he experienced himself; Fearing loved to tell the story of how he and David Stick caught a ride to Kitty Hawk in 1928 to attend the 25th anniversary celebration of the Wright brothers' first flight. At the event, a young woman spotted the two boys flailing around in the back of a pickup in which they had hitched a ride. She jumped into the truck bed and flung her arms around the boys. That young woman turned out to be famous aviator Amelia Earhart. Fearing could also provide historic details from Colonial times, though he was quick to joke that he was not old enough to have experienced them. He also maintained an impressive collection of photographs and books relating to local history. In 1983, Fearing and his friend Joe Kramer established the Rose Buddies, a group of ambassadors who welcome boaters to Elizabeth City with wine and cheese parties and homegrown roses. Fred Fearing passed away in 2007 at age 94. (Courtesy of Museum of the Albemarle.)

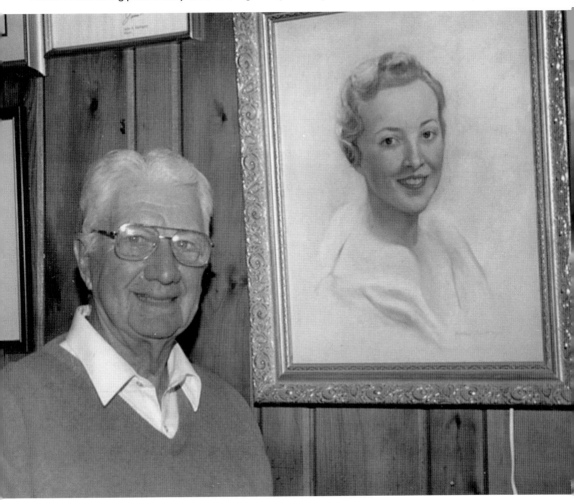

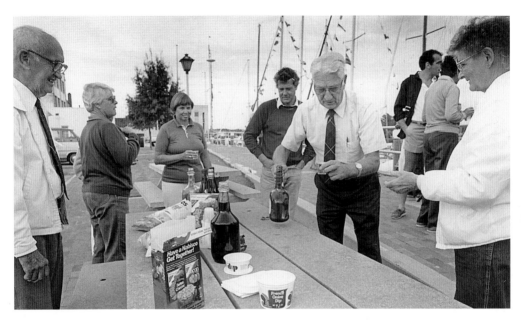

The Rose Buddies

Mariner's Wharf was established in 1983 on the Elizabeth City waterfront to provide free 48-hour dockage to boaters on the Intracoastal Waterway. Downtown residents Fred Fearing and Joe Kramer soon came up with the idea of welcoming boaters to town with wine and cheese parties and Kramer's homegrown roses. Calling themselves The Rose Buddies, the pair became world famous, earning Elizabeth City the moniker "Harbor of Hospitality." The first Rose Buddy party is pictured above. When Kramer passed away in 1987, his rose bushes were transplanted to Mariner's Wharf, where they continue to delight boaters. After Kramer's death, Fearing continued the tradition. Each evening, Fearing would load his golf cart with wine and snacks and head to the waterfront. He would greet boaters in his courtly Southern drawl, and bow to the ladies before presenting them a rose. Over the years, Fearing entertained such luminaries as Walter Cronkite, who once rode out a hurricane here, and Willard Scott of *The Today Show*, who came to town and presented him with a new golf cart in 1985. The last original Rose Buddy, Fearing passed away in 2007, but a loyal group of volunteers keeps the Rose Buddy tradition alive and well today. (Courtesy of Marian Stokes.)

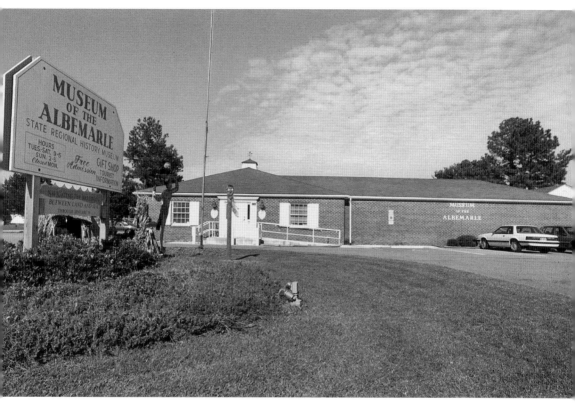

First Site of the Museum of the Albemarle
The first incarnation of the museum was housed in this building on Highway 17. An abandoned highway patrol station, the building was expanded and converted into museum space. (Courtesy of Museum of the Albemarle.)

Museum of the Albemarle

The Museum of the Albemarle interprets the history of the 13-county area of North Carolina's northeast. The museum began as a local grassroots effort. Margaret Hollowell, daughter of Christopher Wilson Hollowell of Bay Side Plantation, was instrumental in beginning the museum's collections. During the Great Depression, Margaret would have her nephew Frank drive her around to local tenant houses where she bartered for furniture, antiques, and other historically valuable objects.

These items would become the core of the museum's collections. Frank and his sister Virginia packed the objects in wooden barrels, which were stored for a time in Wachovia Bank's parking lot. Interest in starting a museum began in the early 1960s when the Pasquotank Historical Society raised special administrative funds to promote the project. Staff from the North Carolina Department of Archives and History in Raleigh came down to view the Hollowells' artifacts, which were displayed in a local church. They determined that there were enough artifacts available to warrant establishing a museum. In 1965, the General Assembly passed a bill to establish a locally administered Museum of the Albemarle. Susan Stitt was hired as the museum's first director in January 1967. She and a group of volunteers spent months unpacking, sorting, cataloging, and cleaning the objects. The Elizabeth City Fire Department's first fire engine, "Inez," was placed on a pedestal in front of the building. The museum opened in May 1967 with Frank Hollowell as president of the board of directors. In 2006, a new state-of-the-art museum building was opened on the Elizabeth City waterfront. A permanent exhibit, "Our Story," interprets 400 years of history in Northeastern North Carolina. The museum continues to serve the Albemarle, with exhibits, seminars, and educational programs. (Author's collection.)

Gwen Madrin

Gwen Madrin was a major figure in the Museum of the Albemarle's early years. As an employee, Madrin would do whatever was required to keep the museum thriving. One minute she would be outside weeding the museum's flower beds, the next she would change her shoes and lead a school tour. At one point, the museum did not have enough money to pay her salary. Board member Woody Foreman, recognizing Madrin's value to the fledgling institution, paid her out of his own pocket for several months. The Madrin Gallery, the largest exhibit area in the new Museum of the Albemarle building, was named in honor of Gwen Madrin. (Courtesy of Museum of the Albemarle.)

Inez

Elizabeth City's first fire engine was a 1902 marvel of metal named "Inez." Shown here with Nancy Bailey, Darlene Jones, and Museum of the Albemarle's first director, Susan Stitt, Inez was a steam-driven vehicle drawn by horses. She was named for Chief G.S. Bell's oldest daughter. Later towed by a motor vehicle, Inez was still in use in 1931. When the fire department retired her, volunteer fireman Robert Jennings salvaged Inez and brought her to Miles Jennings Company's scrap yard. During World War II, when metal was so desirable to the war effort, Jennings hid Inez under a pile of scrap to prevent her from being bought and melted down. After the war, he donated her to the Elizabeth City Fire Department, where she was put on display outside the firehouse. When the Museum of the Albemarle opened on Highway 17 in 1967, Inez took pride of place on a pedestal in front of the building. Today, she is on display in the new Museum of the Albemarle building, part of the permanent exhibit, Our Story. (Courtesy of Museum of the Albemarle.)

Maxine Sweeney

A visit to Maxine Sweeney's house is like being in an art gallery. The portraits she has been painting for decades adorn the walls. "Miss Maxine" started drawing as a very small child, doing good representations of people. Her talent went unnoticed in her early years; public schools did not teach art at that time. After graduating from high school, Maxine told her father she wanted to attend a good art school. He refused, saying she would never make a living as an artist. They eventually reached a compromise. He agreed to send her to art school if she would attend business college afterwards. So Maxine went to the Maryland Institution of Fine Arts in Baltimore, followed by Strayer Business College. After completing her education, she married and moved around a great deal. She worked in banking and other fields, but continued painting. While living in Hialeah, Florida, she began working as a portrait artist. Coming back to Elizabeth City, she became the first art teacher at College of the Albemarle. The COA president's wife, Mrs. Barrington, commissioned her to paint a portrait, and Miss Maxine's portrait business began to grow. She was hired to paint Governor Ehringhaus's portrait to hang in the Pasquotank County Courthouse. She has painted portraits of Judges Small, Cahoon, Watts, and Beamon, which also hang in the courthouse. Over the years, she has painted hundreds of portraits, in oil, pastel, and watercolor, as well as copies of famous paintings. Several years ago, Miss Maxine wrote a children's book, *The Adventures of Buford Bee*, which she illustrated with original watercolors. "I had no idea I was going to write a book," she said. "I don't know where it came from." She has since written a sequel. Maxine is still painting in her backyard studio. She specializes in pastel portraits of small children and heraldic coats of arms. (Courtesy of Maxine Sweeney.)

Mary Frances James

Mary Frances James is the embodiment of the term "strong work ethic." As an agricultural crew leader for nearly 45 years, James has worked all over the region, harvesting crops like potatoes, cabbage, snap beans, and grapes. "I've done it all," James said. "The Lord was good to me and gave me work to do." As a crew leader, James contracted with local farmers to provide seasonal work crews for planting, chopping, and harvesting. Her crews have contained as few as 15 people, and as many as 100, depending on the crop. "People have always come to me looking to join my crew," she recalled. "I'd tell them, 'Alright now, but y'all got to work.'" James and her late husband L.J. produced a family of 19 children, 17 of which lived to adulthood. Being almost constantly pregnant never slowed her down. She would work in the field until she felt labor pains, and never stayed out more than three weeks after a birth. Many of her children are less than a year apart. "That's why they're so stacked up on each other," she said. James and her husband, who constructed houses, instilled their work ethic into all their children. Most of them worked with James in her crew until they found other jobs. Now retired, James enjoys family time with her children and her 40 grandchildren and great-grandchildren. (Courtesy of Mary Frances James.)

The James Family

From left to right are Ledell, Melvin, Joyce, Cecil, Carlton, Larry, Calvin, L.J., Mary Frances, Mary, Evelyn, Vivian, Junior, Barbara, Phyllis, Sandy, Alton, Gary, and Darryl. (Courtesy of Mary Frances James.)

Dr. Lloyd Griffin Jr.

A trip to the dentist can be an entertaining experience if Dr. Lloyd Griffin is your dentist. Take a seat in the chair and Dr. Griffin, who has been practicing for almost 60 years, will regale you with stories from his event-filled life. Born in Edenton, Griffin came to Elizabeth City and began practicing in 1955 after graduating from UNC's school of dentistry. He was instrumental in having fluoride infused into Elizabeth City's drinking water that same year. A world-class sailor, Griffin has competed and won numerous sailing trophies. He was nominated to the North Carolina Sports Hall of Fame at age 71. His wife, Mary Hadley Griffin, shares his enthusiasm for boats and sailing. For many years, she owned and operated the Elizabeth City Ship Yard. The Griffins built many of their own boats there, including their sportfishing boats *Boss Lady* and *Cash Flow*. The couple met in college at a Dixie Classic basketball tournament. "I had better seats than she did," Griffin joked. "That's why she agreed to go out with me." As a youth, Griffin had many adventures. He was working for the highway department one summer when a poisonous snake bit him on the thumb. His hand and arm quickly swelled from the venom. Dr. Williams took one look at his swollen arm and decided to try a new drug called penicillin. Dr. Griffin was therefore the first person in Edenton to be treated with penicillin, and he believes it saved his arm and hand. He played football at McCauley prep school then won a scholarship to play at Wake Forest University but chose to play baseball there instead. As pitcher, he was playing in a game against Yale University when he struck out a certain batter. That batter was future president George Herbert Walker Bush. Also an avid swimmer, Griffin worked as a lifeguard at the Carolinian Hotel at Nags Head during college summers. One summer, British actor Charles Lawton was in town to see *The Lost Colony* outdoor drama. He went swimming behind the Carolinian and got caught in a rip current. Dr. Griffin swam out and got him safely back to shore. He was later rewarded by Lawton's valet, who handed him $100. Dr. Griffin enjoys recounting his adventures, and a visit to his office is never dull. (Courtesy of Lloyd Griffin Jr.)

Dr. William Wassink

Champion bridge player Dr. William "Bill" Wassink practiced medicine for 35 years in Camden County. Born Willem Klein Wassink, he grew up in Nazi occupied Holland during World War II where he faced danger and deprivation. When Holland was invaded, his older brother was sent to a work camp in Berlin. He managed to escape and eventually made his way back to Holland. Dr. Wassink and his younger brother had to be hidden during the daytime to avoid the same fate. Food was so scarce that his family was often forced to eat boiled nettles and tulip bulbs. Dr. Wassink worked as an orderly at a hospital at night and aided the Resistance effort—a dangerous endeavor. If he had been caught helping the Resistance, he would have been shot. Wassink and his brothers were schooled at home by their parents. He would pedal a stationary bike to generate electricity, so the others could see to read. When the university reopened, he took a placement test and had a medical degree by the age of 22. He joined the English Air Force, then was drafted by the Dutch. After graduating from the University of Leiden, he came to America. He was hitch hiking around the country when he met Jessie Pugh in the North Carolina mountains. Pugh, superintendent of the Camden County schools, mentioned that Camden needed a doctor. Dr. Wassink took the North Carolina boards and became an American citizen, Anglicizing his first name to William. His family practice thrived in Camden, until he retired in 1998. A classical violinist and life master at bridge, Dr. Wassink's Dutch accent is still mildly apparent today, as he continues to teach bridge lessons at age 88. (Courtesy of Katherine Wassink.)

Nancy Rascoe

Nancy Dawson Rascoe is the torchbearer of good old-fashioned manners in a world where such niceties are disappearing. Since 1993, "Miss Nancy" has been offering five-day manners camps at her 1812 home on the Perquimans River. Etiquette House Parties for Young Ladies and Gentlemen was born of her grandmother Edna Nixon's strict adherence to etiquette at mealtimes. A former teacher, Miss Nancy had the desire to instruct today's young people in those same good manners. "Etiquette is today what it has always been," she says in her melodious Southern drawl, "a code of behavior based on kindness, consideration, and unselfishness—something that should not, and will not, ever change." The Sunday-through-Thursday house parties instruct children in written correspondence and telephone etiquette, as well as tennis, swimming, and canoeing. The students dress for dinner and learn impeccable table manners. On Thursday, there is a graduation ceremony, with students reciting famous lines from memory. Cell phones and computers pose no distraction for the students; they are not allowed. Born in Elizabeth City, Rascoe is the great-granddaughter of William Crawford Dawson, Elizabeth City's first photographer. Dawson famously rescued the flag when his battalion was defeated in the Battle of Roanoke Island in 1862. He hid the flag in the lining of his coat, and portions of it have passed down to his descendants. Miss Nancy's grandfather W.C. Dawson established the Coca-Cola bottling plant in Elizabeth City. Miss Nancy's Christian faith remains central to her life and all she does. "I couldn't live without it," she says. "My Savior, my shepherd, my friend." (Courtesy of Nancy Rascoe.)

Out N the Cold
From left to right are Red Swain, Dickie Sanders, Kent Luton, Martin Parker, Edgar Lane, Clarence "Moon" Munden, and Robert "Muskrat" Reams.

Elizabeth City's greatest homegrown band has been playing together for 37 years, and they are still going strong. Traditional bluegrass group Out N the Cold got its start by accident at a WCNC radio station Heart Fund benefit in 1977. Kent Luton was home from college for the weekend to sing in the radio-thon. There he ran into Dickie Sanders and Red Swain who were there to play music for the benefit. Kent did not know that Dickie and Red could play, and Dickie and Red did not know Kent could sing. The three brought their talents together and performed on the radio that very night. Kent remarked, "When I get out of college, we should start a band." That fall, music store owner J.J. Harris was looking for a band to play at the county fair. J.J. got together with Kent, Dickie, and Red and formed a group that played its first gig at the fair. After playing together for a time, the band still did not have a name. That came about by accident too. J.J. was leaving the group and taking his sound system with him. The other members went to Norfolk to buy one, but the store had already closed. Sitting around the table at lunch, one of the guys complained, "If we don't get a sound system, we're going to be out in the cold." With that chance remark, the band had found its name. Over the years, Out N the Cold has played at concerts, wedding receptions, and festivals all over the region. They have performed as a group in several Encore Theatre Company musicals, and in the Historic Elizabeth City Ghost Walk. Band members have come and gone over time, but the core group of Kent Luton, Dickie Sanders, and Red Swain has remained. Out N the Cold itself remains a local treasure. (Courtesy of Dickie Saunders.)

The Rescuers of the *Bounty*

On the night of October 29, 2012, an urgent call came in to the US Coast Guard Air Station in Elizabeth City. The tall ship *Bounty* was taking on water 90 miles southwest of Cape Hatteras. The air base dispatched rescue helicopters to the scene—straight into the teeth of Superstorm Sandy. The *Bounty* had left New London, Connecticut, on October 25, bound for St. Petersburg, Florida. Her captain, Robin Walbridge, made the fateful decision to attempt to sail around the massive storm. It was a decision that would cost him his life, and that of one of his crew. When the call came in, every pilot, copilot, technician, and rescue swimmer on duty suited up to fly into the worst weather they had ever seen. It was still dark when the first helicopters took off from Elizabeth City, flying by instrument in the heavy rain and wind. Rescue swimmer Randy Haba and AST3 Daniel Todd were lowered into a raging ocean with 30-foot swells amid gale-force winds. "It was like [being in] a washing machine," Todd recalled. Locating *Bounty* crew members clinging to two life rafts, Haba and Todd were repeatedly lowered into the roiling water, pulling survivors one at a time into baskets that would lift them into the helicopters. Swimming up to the first raft, Todd greeted the survivors with, "Hi, I'm Dan. I heard you guys need a ride." This lighthearted greeting calmed the frantic survivors, letting them know that the Coast Guard was in control and everything would be alright. Over several hours, 14 of the 16 *Bounty* crew members were rescued. One crew member was found unresponsive, floating in the ocean several miles from the others. She did not survive. Other aircraft and Coast Guard cutters were sent out to search for Captain Walbridge. After 90 hours, covering 12,000 nautical miles, the search was suspended. The *Bounty* was a replica of the HMS *Bounty*, whose crew mutinied in 1789. The replica was built in 1962 for the movie *Mutiny on the Bounty* starring Marlon Brando. It also appeared in *Pirates of the Caribbean* with Johnny Depp. Rescuers Haba and Todd received the Distinguished Flying Cross for their part in the rescue. They and 23 other Coast Guardsmen from Air Station Elizabeth City were recognized in a ceremony on June 26, 2013, for their heroic efforts in saving the crew members of the *Bounty*. The photograph is by Brandyn Hill. (Courtesy of US Coast Guard.)

Bounty Survivors Survivors of the *Bounty* arrive at Air Station Elizabeth City, October 30, 2012. The photograph is by Brandyn Hill. (Courtesy of US Coast Guard.)

Edward Snowden Considered by some to be a hero and others a traitor, it is hard to tell if he is a whistleblower or a dissident. It depends on who one asks, but Edward Snowden has certainly caused an international stir. Snowden was born in Elizabeth City on June 21, 1983. A former CIA employee, he was working for defense contractor Booz Allen Hamilton as a computer specialist when he released classified documents to various media outlets. Snowden justified his actions, saying the NSA overstepped its bounds, prying into the private lives of American citizens with its surveillance methods. He maintained that he was following his conscience in an effort to protect Americans from undue government intrusion. Many consider Snowden's actions the most significant leak in US history. He is currently living in Russia, which has granted him temporary asylum. Snowden's actions have started a national conversation about the balance between national security and individual privacy. He is considered a fugitive by American authorities. Some media outlets and politicians have called for clemency for Snowden, while others believe he should be imprisoned or put to death. Snowden maintains that he feels satisfied that his actions were worth it. "I have no regrets," he has said. (Courtesy of Ars Technica.)

INDEX

AN IMPRINT OF ARCADIA PUBLISHING

Find more books like this at
www.legendarylocals.com

Discover more local and regional history books at
www.arcadiapublishing.com